2000
YEARS
SINCE
BETHLEHEM

𝒥MAGES OF CHRIST
THROUGH THE
CENTURIES

COMPILED BY

JANICE T. GRANA

THE MILLENNIUM BOOK

UPPER
ROOM BOOKS
NASHVILLE

2000 YEARS SINCE BETHLEHEM
IMAGES OF CHRIST THROUGH THE CENTURIES
© 1998 by The Upper Room
All rights reserved.

The Upper Room Web Site: http://www.upperroom.org

Scripture quotations which are identified as NRSV are from the New Revised Standard Version of the Bible © 1989 by the Division of Christian Education of the National Council of the Churches in Christ in the USA. Used by permission. All rights reserved.

The publisher gratefully acknowledges permission to reproduce the copyrighted material appearing in this book. Credit lines for this material appear in the Notes and Permissions Section which begins on page 129.

Art Direction and Cover Design: Harriette Bateman
Interior Design: Harriette Bateman
Interior Layout: Nancy Cole

First printing: 1998

Library of Congress Cataloging-in-Publication Data
2000 years since Bethlehem / compiled by Janice T. Grana.
 p. cm.
 ISBN 0-8358-0865-3
 1. Jesus Christ—Quotations. I. Grana, Janice.
BT199.A15 1999 98-37056
232—dc2 CIP

Printed in the United States of America on acid-free paper

CONTENTS

FOREWORD vii
PREFACE xi
ACKNOWLEDGMENTS xv

First Century 1
Second Century 7
Third Century 13
Fourth Century 15
Fifth Century 21
Sixth Century 29
Seventh Century 31
Eighth Century 33
Ninth Century 35
Tenth Century 39
Eleventh Century 41
Twelfth Century 43
Thirteenth Century 47
Fourteenth Century 51
Fifteenth Century 59
Sixteenth Century 63
Seventeenth Century 71
Eighteenth Century 77
Nineteenth Century 87
Twentieth Century 97

NOTES AND PERMISSIONS 129
INDEX OF READINGS AND CONTRIBUTORS 139

FOREWORD

\mathcal{F}or more than two decades I have participated in the annual meeting of the Conference of Secretaries of Christian World Communions. The Conference is composed of the general secretaries and other leaders of churches and denominational alliances whose membership together represents approximately one-third of the world's population. In the mid-1990s the Conference began to consider ways Christians at the turn of the millennium might celebrate the 2000th anniversary of the birth of Christ. We wanted to invite persons around the world to see this as a time of renewal and commitment to Jesus Christ.

One idea was to prepare a special millennium book that would contain the writings of persons from the ancient churches of the East and West and those new faith communions which have emerged over the more recent centuries. We hoped this book could help us listen to the past voices of the church and find a renewed vision for the future.

This devotional book for the new millennium—2000 *Years since Bethlehem: Images of Christ through the Centuries*—is the result. Janice T. Grana, who for many years served as the World Editor and Publisher of The Upper Room, compiled this volume. An advisory panel of international Christian leaders submitted writings and reviewed the manuscript. The brief writings from every Christian tradition span the ages. They speak forcefully to persons like us who are entering a new millennium.

The book is not something to be read through in one sitting and then put away on the shelf. These selected passages are intended to be read and reread until we see the Light that illumined the path of the writers. Through the power of God, that Light continues to shine for all who earnestly desire to see life and the future through new eyes of faith. The selections were written over the past two thousand years, but they breathe with freshness and life for the new millennium.

These writings also call us into action. Many living today have not clearly heard the witness of those who see Jesus Christ as the defining fact of their lives. The impetus to tell others about the love of Christ and the new life God offers is the thread that unites all these writings from persons who lived in such different times and cultures.

This book is designed be read in brief moments in an airport, while waiting for an appointment, or at the in-between times, to stimulate prayer and reflection. It can be a companion for us as we discover passages appropriate for particular days that open up new ways to see Christ in our lives. When I became a Christian, I was given a small pocket book of Christian witness and prayer. I carried it with me through college, graduate school, and my early years of work. It nurtured my faith because it was a constant reminder of Christ, and it helped me to look at my days in the light of the Good News.

This book will appreciate in value as you read it, for in its pages there is a seamless witness that began in Palestine, then spread to the east, the west, the north, and the south. The writers share vividly the

Light they saw and experienced. Their words will illu-
mine our paths if we keep company with them. They
beckon us to set our eyes on Jesus Christ and join the
procession of the faithful from Bethlehem into the
future.

JOE HALE
General Secretary, World Methodist Council
Chairperson (1982-1986), Conference of Secretaries
Christian World Communions

PREFACE

A new millennium—what significance does this have for you and for me? What feelings, what concerns, what questions does this time of transition prompt? Many writers, commentators, and social scientists are telling us that this is a calendar watershed, a turning point in history that is likely to cause much anxiety and soul-searching. Obviously it is daunting to image ourselves living in the twenty-first century and finding meaning and stability amidst the ever-accelerating changes in our society. What will be the touchstones of wisdom and insight that will guide our paths as we face the challenges before us?

This collection of writings is designed to be of assistance as we seek to reflect on the future and the spiritual journey which lie before us. In the two thousand years since the birth of Christ, men and women in all parts of the world have found that the key to the present and to the future has been centering their lives in Christ. They have sought to understand his unique life and death and discover what it means to follow him in the circumstances of their lives.

This compilation includes the writings of persons from each of the twenty centuries since Christ's birth. The excerpts are brief, but they convey rich and colorful images of Christ and his impact on their lives. Consider that the Epistle of Barnabas in the second century described Christ as the true and eternal milk and honey by which we will be fed and given understanding. John Climacus in the seventh century called Christ the Sun whose light we can see as we become accustomed to the light through meekness and humility. Julian of Norwich in the fourteenth century writes

of Jesus as our mother who enfolds us in love, and Catherine of Siena envisions Christ as the true bridge between humanity and God so that we might pass over the bitterness of the world and reach life. Each of these persons was seeking to express in simple, understandable language how his or her life had been reshaped and given new meaning through the presence of the living Christ. The language and the images are strikingly different, but each selection adds nuances of lived meaning as these persons try to capture the difference that Christ has made for them.

Teresa of Avila reminds us in the opening pages of her autobiography that the best way to know and love God is to live in the company of God's friends. This compilation brings together a host of God's friends who have much to teach us about Jesus Christ. Their view of history is rooted in the conviction that the true turning point of time is the birth and life of Jesus Christ, and that life in every age can be understood only from the perspective of Emmanuel—God with us, now and forever.

I hope that this compilation will provide for you a stimulating time of discovery. I know that it has been such for me as I worked on this project. As you read each of the selections, I would invite you to explore the following questions:

- ∽ What new understandings of Christ are to be found in this person's writing?
- ∽ How does this person's experience connect to mine?
- ∽ What new thing might Christ be showing me?
- ∽ How do I open myself afresh to what Christ is offering?

~ How does this change the way I see myself, the way I see the future, the way I see my life?

I am indebted to Sarah Schaller-Linn for her work in securing permissions for the writings included in this volume. We attempted to use the most accessible translations or editions. The language reflects the period in which each was written, but the challenge of finding meaning in life is common to all the men and women whose writings are included. Please read the book in a spirit of expectancy that God can use these words to bring a new vision of hope and promise to each of us. I pray that you will see these persons as your brothers and sisters in Christ, whose faith can enrich and deepen your spiritual life. In the two thousand years since Bethlehem, the presence of the living Christ has transformed human lives and transformed history. The same Christ is now transforming us and our time.

JANICE T. GRANA

ACKNOWLEDGMENTS

\mathcal{M}y deep gratitude goes to each of the following persons who supported this project and agreed to serve as an advisory group for the selection of materials for the book:

Cardinal Edward Idris Cassidy, President of the Pontifical Council for Promoting Christian Unity, Vatican City, Italy

Dr. Joe Hale, General Secretary, World Methodist Council, Lake Junaluska, North Carolina

Dr. Denton Lotz, General Secretary, Baptist World Alliance, Washington, D.C.

Dr. Ishmael Noko, General Secretary, The Lutheran World Federation, Geneva, Switzerland

Dr. Milan Opočenský, General Secretary, World Alliance of Reformed Churches, Geneva, Switzerland

The Reverend Canon John L. Peterson, Secretary General, The Anglican Communion, London, England

General Paul Rader, Headquarters, The Salvation Army, London, England

Dr. George Tsetsis, Grand Protopresbyter, Permanent Representative of the Ecumenical Patriarchate, Geneva, Switzerland

FIRST CENTURY

~~~~~~~~~~~~~~~~~~~~~~~~~~~~~~

## A MIGHTY SAVIOR

*B*lessed be the Lord God of Israel,
  for he has looked favorably on his people
  and redeemed them.
He has raised up a mighty savior for us
  in the house of his servant David,
as he spoke through the mouth of his holy
  prophets from of old,
that we would be saved from our enemies
  and from the hand of all who hate us.
Thus he has shown the mercy promised
  to our ancestors, and has remembered
his holy covenant, the oath that he swore
  to our ancestor Abraham, to grant us
that we, being rescued from the hands
  of our enemies, might serve him
without fear, in holiness and righteousness
  before him all our days.
And you, child, will be called the prophet
  of the Most High; for you will go before
the Lord to prepare his ways, to give knowledge
  of salvation to his people by the
  forgiveness of their sins.
By the tender mercy of our God,
  the dawn from on high will break upon us,
to give light to those who sit in darkness
  and in the shadow of death,
to guide our feet into the way of peace.

—Zechariah (Lk. 1:68-79, NRSV)

## THE CROOKED BE MADE STRAIGHT

The voice of one crying out in the wilderness:
"Prepare the way of the Lord,
    make his paths straight.
Every valley shall be filled,
    and every mountain and hill shall be made low,
    and the crooked shall be made straight,
    and the rough ways made smooth;
and all flesh shall see the salvation of God."

—John the Baptist, using the words of
the prophet Isaiah (Lk. 3:4-6, NRSV)

## MY EYES HAVE SEEN

Master, now you are dismissing your servant in
    peace, according to your word;
for my eyes have seen your salvation,
    which you have prepared in the presence
    of all peoples,
a light for revelation to the Gentiles
    and for glory to your people Israel.

—Simeon (Lk. 2:29-32, NRSV)

## THE HOLY ONE OF GOD

Because of this many of his disciples turned back
and no longer went about with him. So Jesus asked
the twelve, "Do you also wish to go away?" Simon
Peter answered him, "Lord, to whom can we go? You
have the words of eternal life. We have come to
believe and know that you are the Holy One of God."

—Simon Peter (Jn. 6:66-69, NRSV)

## THE MESSIAH

*Y*ou are the Messiah, the Son of the living God.

—Peter (Mt. 16:16, NRSV)

## I HAVE SEEN THE LORD

*B*ut Mary stood weeping outside the tomb. As she wept, she bent over to look into the tomb; and she saw two angels in white, sitting where the body of Jesus had been lying, one at the head and the other at the feet. They said to her, "Woman, why are you weeping?" She said to them, "They have taken away my Lord, and I do not know where they have laid him." When she had said this, she turned around and saw Jesus standing there, but she did not know that it was Jesus. Jesus said to her, "Woman, why are you weeping? Whom are you looking for?" Supposing him to be the gardener, she said to him, "Sir, if you have carried him away, tell me where you have laid him, and I will take him away." Jesus said to her, "Mary!" She turned and said to him in Hebrew, "Rabbouni!" (which means Teacher). Jesus said to her, "Do not hold on to me, because I have not yet ascended to the Father. But go to my brothers and say to them, 'I am ascending to my Father and your Father, to my God and your God.'" Mary Magdalene went and announced to the disciples, "I have seen the Lord"; and she told them that he had said these things to her.

—Mary Magdalene (Jn. 20:11-18, NRSV)

## IN HIM ALL THINGS HOLD TOGETHER

 $\mathcal{M}$ ay you be made strong with all the strength that comes from his glorious power, and may you be prepared to endure everything with patience, while joyfully giving thanks to the Father, who has enabled you to share in the inheritance of the saints in the light. He has rescued us from the power of darkness and transferred us into the kingdom of his beloved Son, in whom we have redemption, the forgiveness of sins.

He is the image of the invisible God, the firstborn of all creation; for in him all things in heaven and on earth were created, things visible and invisible, whether thrones or dominions or rulers or powers— all things have been created through him and for him. He himself is before all things, and in him all things hold together. He is the head of the body, the church; he is the beginning, the first-born from the dead, so that he might come to have first place in everything. For in him all the fullness of God was pleased to dwell, and through him God was pleased to reconcile to himself all things, whether on earth or in heaven, by making peace through the blood of his cross.

And you who were once estranged and hostile in mind, doing evil deeds, he has now reconciled in his fleshly body through death, so as to present you holy and blameless and irreproachable before him—provided that you continue securely established and steadfast in the faith, without shifting from the hope promised by the gospel that you heard, which has been proclaimed to every creature under heaven. I, Paul, became a servant of this gospel.

—Paul (Col. 1:11-23, NRSV)

## THE NAME ABOVE EVERY NAME

$\mathcal{L}$et the same mind be in you that was in Christ Jesus,
who, though he was in the form of God,
did not regard equality with God
as something to be exploited,
but emptied himself, taking the form of a slave,
being born in human likeness.
And being found in human form, he humbled
himself
and became obedient to the point of death—
even death on a cross.

Therefore God also highly exalted him
and gave him the name that is above every
name,
so that at the name of Jesus
every knee should bend,
in heaven and on earth and under the earth,
and every tongue should confess
that Jesus Christ is Lord,
to the glory of God the Father.

—Paul (Phil. 2:5-11, NRSV)

## A ROOT IN THIRSTY GROUND

$\mathcal{I}$t is to the humble that Christ belongs, not to those
who exalt themselves above his flock. The scepter of
God's majesty, the Lord Jesus Christ, did not come
with the pomp of pride or arrogance, though he could
have done so. But he came in humility just as the
Holy Spirit said of him. For Scripture reads: "Lord,
who has believed what we heard? And to whom has
the arm of the Lord been revealed? Before him we
announced that he was like a child, like a root in

thirsty ground. He has no comeliness or glory. We saw him, and he had neither comeliness nor beauty. But his appearance was ignominious, deficient when compared to man's stature. He was a man marred by stripes and toil, and experienced in enduring weakness. Because his face was turned away, he was dishonored and disregarded. He it is who bears our sins and suffers pain for us. And we regarded him as subject to toil and stripes and affliction. But it was for our sins that he was wounded and for our transgressions that he suffered. To bring us peace he was punished: by his stripes we were healed."

—Clement of Rome

## CHRIST IS THE SOURCE OF AUTHORITY

Let us think ourselves like an army, with Christ as our general giving faultless commands. . . . So let us always look to Christ, our general, as the source of authority. Let us be obedient to those whom Christ has appointed as our pastors. And let us carry out our duties with diligence. In this way the strong will help the weak, and the weak will serve the strong. The rich will care for the poor, and the poor will pray for the rich. The wise [person] will guide those new to the faith, and the new converts will inspire the wise with their zeal.

—Clement of Rome

# SECOND CENTURY

## MY KING

*E*ighty and six years have I served Him, and He hath done me no wrong, How then can I speak evil of my King who saved me?

—Polycarp of Smyrna

## OUR SOURCE OF HOPE

*C*hrist is our hope, and in that hope we find courage to persevere through all trials, temptations, and hardships. Let us imitate the endurance of Christ, who suffered and died for our sake. Remember Ignatius, Zosimus, and Rufus, as well as Paul himself, who suffered and died for their faith in Christ. They did not run the course of life in vain, but in death they received the crown of glory. When you feel weak in the faith, draw closer together for mutual support, that together you may be strong. When your mind becomes distracted by worldly concerns, concentrate your attention on the needs of others and work even harder to satisfy those needs. Above all, do not allow your faith to be perverted by false teaching. There are always people who are prepared to pervert the words of Christ for their own purposes, and to deny the final judgment in order to persuade themselves and others that they can sin without fear of punishment. Do not even listen to such people, but turn your back on them.

—Polycarp of Smyrna

## TRUE AND ETERNAL MILK AND HONEY

*W*e have been created anew in Christ Jesus; our hearts of stone have become hearts of flesh. In truth, Jesus himself lives within our hearts, so our bodies become temples of his Spirit. And he also lives amongst us, binding us together in love. In days of old the Hebrew people were promised a land of milk and honey. We have now received the true and eternal milk and honey. A child is first nourished with milk, and then with honey. In the same way, Christ nourishes us with spiritual milk when we first come to faith, feeding us the aspects of the truth that we can understand. Then he begins to feed us the spiritual honey of divine joy, pouring his love into our souls until we are overflowing with praise and thanksgiving.

—The Epistle of Barnabas

## THE ONE WHO DWELLS WITHIN

*I*t is better to be silent and be real, than to talk and be unreal. Teaching is good, if the teacher practices what he advises. The best teaching is not by words but by example. He who truly possesses the words of Jesus Christ in his heart hears those words constantly within the silence of his heart; and his every action expresses Christ's love. Nothing is hidden from Christ, for he can read our innermost thoughts. So let us do all things as if he were dwelling within us, that we may be his temples, and our actions become like hymns of praise. Beware false teachers, whose mouths are filled with eloquent words but who do not know the words of Jesus in their hearts. Only accept the

teaching of those whose lives demonstrate the truth of what they are saying. Better to hear no verbal teaching at all than to risk hearing words of corruption. Each of you who knows Jesus can hear his words within your heart and can teach others by your action.

—Ignatius of Antioch

## POINTING TO CHRIST

You have never envied anyone, but only taught people the way of Christ. I desire only that I may stay firmly on that way. Please pray for me, that I may have both spiritual and physical strength to perform my duties; that I may not only speak the truth, but become the truth; that I may not only be called a Christian, but also live like a Christian. Yet I do not want people to look to me as an example, for at best I can only be a pale reflection of Christ Jesus; let people look away from the reflection and turn to the reality. Christianity is not a matter of persuading people of particular ideas, but of inviting them to share in the greatness of Christ. So pray that I may never fall into the trap of impressing people with clever speech, but instead I may learn to speak with humility, desiring only to impress people with Christ himself.

—Ignatius of Antioch

# THE ONE WHO DISPELS OUR CLOUDS

$\mathscr{B}$rothers, we ought to think of Jesus Christ as we do of God—as the "judge of the living and the dead." And we ought not to belittle our salvation. For when we belittle him, we hope to get but little; and they that listen as to a trifling matter, do wrong. And we too do wrong when we fail to realize whence and by whom and into what circumstances we were called, and how much suffering Jesus Christ endured for us. How, then, shall we repay him, or what return is worthy of his gift to us? How many blessings we owe to him! For he has given us light; as a Father he has called us sons; he has rescued us when we were perishing. How, then, shall we praise him, or how repay him for what we have received? Our minds were impaired; we worshiped stone and wood and gold and silver and brass, the works of [humans]; and our whole life was nothing else but death. So when we were wrapped in darkness and our eyes were full of such mist, by his will we recovered our sight and put off the cloud which infolded us. For he took pity on us and in his tenderness saved us, since he saw our great error and ruin, and that we had no hope of salvation unless it came from him. For he called us when we were nothing, and willed our existence from nothing.

—Anonymous (referred to as Clement's
Second Letter to the Corinthians)

# A PARTICULAR HISTORY

𝒯he Church is now scattered over the whole civilized world to the ends of the earth. But it was founded in a particular place at a particular time by a particular person, Jesus Christ. And he appointed apostles to teach the world that there is one God, the Father almighty, who made heaven and earth and sea and all that lives in them; that he, Jesus Christ, is the Son of God, made flesh for our salvation; and that through the Holy Spirit all people may be led to know him as their Lord. The apostles also related the full story of Jesus Christ: his birth by a virgin; his suffering and resurrection from the dead; and his ascension into heaven. And they taught that he will return from heaven to restore all things to perfection, and to raise up the whole human race, so that all may bend their knee to him in adoration, and acknowledge him as King of the universe. At that time, all those who have rejected him, or who first accepted him and then under pressure turned away from him, will be banished and sent into the eternal fire of hell. But the righteous and holy, who have kept his commandments and remained in his love, will be clothed in eternal glory.

—Irenaeus

# THIRD CENTURY

~~~~~~~~~~~~~~~~~~~~~~~~~~~~~~

NEVER MOVING FROM HIS WATCHTOWER

*B*ut most perfect and most holy of all, most sovereign, most lordly, most royal, and most beneficent, is the nature of the Son, which approaches most closely to the One Almighty Being. The Son is the highest pre-eminence, which sets in order all things according to the Father's will, and steers the universe aright, performing all things with unwearying energy, beholding the Father's secret thoughts through his working. For the Son of God never moves from his watchtower, being never divided, never dissevered, never passing from place to place, but existing everywhere at all times and free from all limitations. He is all reason, all eye, all light from the Father, seeing all things, hearing all things, knowing all things, with power searching the powers. To him is subjected the whole army of angels and of gods—to him, the Word of the Father, who has received the holy administration by reason of him who subjected it to him; through whom also all [people] belong to him, but some by way of knowledge, while others have not yet attained to this; some as friends, some as faithful servants, others as servants merely.

—Clement of Alexandria

THE ROCK

*L*ong ago we heard Jesus' words, and it is now in the distant past that we were made disciples of the gospel, and all built for ourselves a house. Where we have built, whether we have dug deep and founded it on the rock, or on the sand without any foundation, the present struggle will show. For a storm is imminent bringing rain and rivers and winds, or, as Luke says, flood-water. When these break upon the house, either they will not be able to shake it, and the house will not fall for the reason that it is built upon the rock, on Christ, or they will show up the weakness of the building which will fall under the blows of the tempest. May this never happen to our buildings.

—Origen

THE HIDDEN LIFE

*W*hat sort of life shall we live when we are no longer living under the shadow of life but are in life itself. For now "our life is hid with Christ; but when Christ, who is our life, shall appear, then shall we also appear with him in glory." Let us haste towards this life, groaning and grieving that we are in this tent, that we dwell in the body. So long as we are present in the body, we are absent from the Lord. Let us long to be absent from the body and to be present with the Lord, that being present with him we may become one with the God of the universe and his only begotten Son, being saved in all things and becoming blessed, in Jesus Christ, to whom be the glory and the power for ever and ever. Amen.

—Origen

FOURTH CENTURY

~~~~~~~~~~~~~~~~~~~~~~~~~~~~~~~

## LEADING US THROUGH HIMSELF

$\mathscr{M}$oreover [Christ is called] Light, as being the brightness of souls cleansed by word and life. For if ignorance and sin be darkness, knowledge and a godly life will be light. And [he is called] Life because he is Light, and is the constituting and creating power of every reasonable soul. For "in him we live, and move, and have our being," according to the double power of that breathing into us; for we were all inspired by him with breath, and as many of us as were capable of it, and in so far as we open the mouth of our mind, with the Holy Ghost. . . .

. . . He is the way, because he leads us through himself; the door, as letting us in; the shepherd, as making us dwell in a place of green pastures, and bringing us up by waters of rest, and leading us there, and protecting us from wild beasts, converting the erring, bringing back that which was lost, binding up that which was broken, guarding the strong, and bringing them together in the fold beyond.

—Gregory of Nazianzus

## HE BECAME LIKE US

$\mathscr{I}$n His goodness, God the Father "spared not his own" only-begotten "Son, but delivered him up" (Rom. 8:32) to free us of our sins and wrongdoings. And the Son of God, humbling Himself for our sakes, cured us of the ills of our soul and provided salvation from our sins. I exhort you in the name of our Lord Jesus Christ,

always to keep in mind and be aware of this great Divine Dispensation, that is, that for our sake God the Word became like us in all things save sin. It behoves those who have the gift of reason, to use it for this knowledge, and to strive to become free (from sins) in actual deed, by virtue of the Lord coming to us.

—Antony of Egypt

## THE FIRE HE SENDS

With all my strength I pray God for you, that He may send into your hearts that fire, which our Lord Jesus Christ has come to send on the earth (Lk. 12:49), that you may have power to govern rightly your intentions and senses and to distinguish good from evil.

—Antony of Egypt

## HANDS THAT EMBRACE THE WHOLE WORLD

He had laid wood against wood, and hands against hands: His generously extended hands against those that reach out with greed; His nail-pierced hands against those that are fallen in discouragement; His hands that embrace the whole world against the hand that brought about Adam's banishment from Paradise.

Yesterday I hung on the Cross with Christ; today I am glorified with Him; yesterday I was dying with Him, today I am brought to life with Him; yesterday I was buried with Him, today I rise with Him.

Let us become like Christ, since Christ also became like us. Let us become gods for Him, since He became man for us.

—Gregory of Nyssa

## TAKEN UP RESIDENCE WITH US

And like as when a great king has entered into some large city and taken up his abode in one of the houses there, such city is at all events held worthy of high honor, nor does any enemy or bandit any longer descend upon it and subject it; but, on the contrary, it is thought entitled to all care, because of the king's having taken up his residence in a single house there; so, too, has it been with the monarch of all. For now that he has come to our realm, and taken up his abode in one body among his peers, henceforth the whole conspiracy of the enemy against [humankind] is checked, and the corruption of death which before was prevailing against them is done away.

—Athanasius

## THE WORD REVEALED EVERYWHERE

This too is what Paul means to point out when he says: "That ye, being rooted and grounded in love, may be strong to apprehend with all the saints what is the breadth and length, and height and depth, and to know the love of Christ which passeth knowledge, that ye may be filled unto all the fullness of God." For by the Word revealing himself everywhere, both above and beneath, and in the depth and in the breadth—above, in the creation; beneath, in becoming man; in the depth, in Hades; and in the breadth, in the world—all things have been filled with the knowledge of God. Now for this cause, also, he did not immediately upon his coming accomplish his sacrifice on behalf of all, by offering his body to death and raising it again, for by this means he would have made himself invisible. But he made himself visible

enough by what he did, abiding in it, and doing such works, and showing such signs, as made him known no longer as man, but as God the Word. For by his becoming man, the Saviour was to accomplish both works of love: first, in putting away death from us and renewing us again; secondly, being unseen and invisible, in manifesting and making himself known by his works to be the Word of the Father, and the ruler and king of the universe.

—Athanasius

## CHRIST BRINGS SIGHT

$\mathcal{D}$o not puff yourself up for shedding tears in your prayer, for it is Christ Who has touched your eyes and has given you inner sight.

—Mark the Ascetic

## BRINGS GIFTS TO THE HEARER

$\mathcal{E}$very word of Christ shows Divine mercy, righteousness and wisdom and, through the ear, brings its force into the souls of those who hear it willingly. This is why the unmerciful and unrighteous men, who heard it unwillingly, could not only not understand the Divine wisdom, but crucified Him Who taught it. So we too must see whether we hear Him willingly.

—Mark the Ascetic

## HE DIED TO BRING LIFE

*O*h, the new and ineffable mystery! the Judge was judged. He who absolves from sin was bound; He was mocked who once framed the world; He was stretched upon the cross who stretched out the heavens; He was fed with gall who gave the manna to be bread; He died who gives life. He was given up to the tomb who raises the dead. The powers were astonished, the angels wondered, the elements trembled, the whole created universe was shaken, the earth quaked, and its foundations rocked; the sun fled away, the elements were subverted, the light of day receded; because they could not bear to look upon their crucified Lord. . . .

What, I say, is this mystery? The creature surely is transfixed with amazement. But when our Lord rose from death and trampled it down, when He bound the strong man and set man free, then every creature wondered at the Judge who for Adam's sake was judged, at the invisible being seen, at the impassable suffering, at the immortal dead, at the celestial buried in the earth. For our Lord was made man; He was condemned that He might impart compassion; He was bound that He might set free; He was apprehended that He might liberate; He suffered that He might heal our sufferings; He died to restore life to us; He was buried to raise us up.

—Alexander

# THE NAMES OF OUR SAVIOR

In the Holy Scriptures there are many names and titles which are applied to Our Lord and Saviour, Jesus. He is said to be the Word: He is called Wisdom, Light and Power, right hand, and angel, man and lamb and sheep and priest, He is the Way, the Truth, the Life, a vine, Justice and Redemption, bread, a stone and doctor, a fount of living water, peace and judge and door. Yet, for all these names which are to help us grasp the nature and range of His power, there is but one and the same Son of God who is our God. These many names and titles belong to one Lord. Take courage, therefore, . . . and plant your hope firmly in Him. If you would learn of the Father, listen to this Word. If you would be wise, ask Him Who is Wisdom. When it is too dark for you to see, seek Christ, for He is the Light. Are you sick? Have recourse to Him Who is both doctor and health. Would you know by whom the world was made and all things are sustained? Believe in Him for He is the arm and right hand. Are you afraid of this or that? Remember He will stand beside you like an angel. If you are innocent, like a lamb He will join your company. If you are saddened by persecution, take courage. Remember that He Himself went like a lamb to the slaughter, and, priest that He is, He will offer you up as a victim to the Father. If you do not know the way of salvation, look for Christ, for He is the road for souls. If it is truth that you want, listen to Him, for He is the truth. Have no fear whatever of death, for Christ is the Life of those who believe.

—Niceta of Remesiana

# FIFTH CENTURY

~~~~~~~~~~~~~~~~~~~~~~~~~~~~~~~

WHO IS LIKE YOU, O LORD?

O Lord, I am your servant, I am your servant and your handmaid's son. You burst my bonds asunder, and to you will I offer a sacrifice of praise. May my heart and tongue give praise to you, and all my bones cry out their question, "Who is like you, O Lord?" Yes, let them ask, and then do you respond and say to my soul, I am your salvation.

But who am I, what am I? Is there any evil I have not committed in my deeds, or if not in deeds, then in my words, or if not in words, at least by willing it? But you, Lord, are good and merciful, and your right hand plumbed the depths of my death, draining the cesspit of corruption in my heart, so that I ceased to will all that I had been wont to will, and now willed what you willed. But where had my power of free decision been throughout those long, weary years, and from what depth, what hidden profundity, was it called forth in a moment, enabling me to bow my neck to your benign yoke and my shoulders to your light burden, O Christ Jesus, my helper and redeemer? How sweet did it suddenly seem to me to shrug off those sweet frivolities, and how glad I now was to get rid of them—I who had been loath to let them go! For it was you who cast them out from me, you, our real and all-surpassing sweetness. You cast them out and entered yourself to take their place, you who are lovelier than any pleasure, though not to flesh and blood, more lustrous than any light, yet more inward than is any secret intimacy, loftier than all honor, yet not to those who look

for loftiness in themselves. My mind was free at last from the gnawing need to seek advancement and riches, to welter in filth and scratch my itching lust. Childlike, I chattered away to you, my glory, my wealth, my salvation, and my Lord and God.

—Augustine

WE ARE CHANGED THROUGH HIM

Now, therefore, let us walk in hope, and let us by the spirit mortify the deeds of the flesh, and so make progress from day to day. For "the Lord knoweth them that are His;" and "as many as are led by the Spirit of God, they are sons of God," but by grace, not by nature. For there is but one Son of God by nature, who in His compassion became Son of man for our sakes, that we, by nature sons of men, might by grace become through Him sons of God. For He, abiding unchangeable, took upon Him our nature, that thereby He might take us to Himself; and, holding fast His own divinity, He became partaker of our infirmity, that we, being changed into some better thing, might, by participating in His righteousness and immortality, lose our own properties of sin and mortality, and preserve whatever good quality He had implanted in our nature, perfected now by sharing in the goodness of His nature. For as by the sin of one man we have fallen into a misery so deplorable, so by the righteousness of one Man, who also is God, shall we come to a blessedness inconceivably exalted.

—Augustine

MY HOPE IN CHRIST IS STRONG

*H*ow much you have loved us, Good Father, who "did not spare your only Son, but delivered Him up for us" (Rom. 8:32), the ungodly! How you have loved us, for whom "He who thought it not robbery to be equal with you was made subject even to the death of the cross" (Phil. 2:6, 8). He "alone free among the dead, having power to lay down His life, and power to take it up again" (Ps. 88:5): For us He was to you both victor and victim (Jn. 10:18) and victor because victim: For us He was to you both priest and sacrifice, and priest because sacrifice: and He made us sons to you instead of slaves by being born of you and becoming your slave. Deservedly, then, my hope in Him is strong, that "you will heal all my infirmities" (Ps. 102:3) through Him who "sits at your right hand making intercession for us" (Rom. 8:34), otherwise I should despair. For many and great are my infirmities, yes, many and great; but your medicine is still greater. . . .

Terrified by my sins and the burden of my misery I pondered in my heart about a plan to fly to the wilderness. But you forbade me and strengthened me, saying, "Therefore Christ died for all, that they who live may now no longer live unto themselves, but unto Him who died for them" (2 Cor. 5:15). See, Lord, "I cast my care upon you" (Ps. 55:22) that I may live and "consider the wondrous things of Your law" (Ps. 119:8). You know my unskillfulness and my weakness; teach me and heal me. He, your only Son, "in whom are hid all the treasures of wisdom and knowledge" (Col. 2:3), has redeemed me with His blood. "Let not the proud speak evil of me" (Ps. 119:22) for I meditate on the price of my redemption. I eat it and drink it and give it to others. And being poor myself, I desire

to be satisfied by it among those who "eat and are sat-
isfied, and they shall praise the Lord who seek Him"
(Ps. 31:16).
 —Augustine

HE SEES US SEEKING HIM

𝒯herefore, strive to please the Lord, always waiting
expectantly for him from within, seeking him in your
thoughts and forcing and compelling your own will
and deliberation to stretch out always toward him.
And see how he comes to you and makes his abode in
you (Jn. 14:23). For as much as you concentrate your
mind to seek him, so much more does he, by his own
tender compassion and goodness, come to you and
give you rest. He stands, gazing on your mind, your
thoughts, your desires. He observes how you seek
him—whether with your whole soul, with no sloth,
with no negligence.

And when he sees your earnestness in seeking him,
then he appears and manifests himself to you. He gives
you his own help and makes the victory yours, as he
delivers you from your enemies. For when he first sees
you seeking after him, and how you are totally wait-
ing expectantly without ceasing for him, he then
teaches and gives you true prayer, genuine love,
which is himself made all things in you: paradise, tree
of life, pearl, crown, builder, cultivator, sufferer, one
incapable of suffering, man, God, wine, living water,
lamb, bridegroom, warrior, armor, Christ, all in all.

Indeed, just as an infant does not know how to take
care of itself or do for itself, but only looks to its
mother, as it cries, until she, moved by pity, picks it
up, so faithful persons constantly hope only in the
Lord, attributing all justice to him.
 —Pseudo-Macarius

THE TRANSFORMATION CHRIST BRINGS

Whoever approaches God and truly desires to be a partner of Christ must approach with a view to this goal, namely, to be changed and transformed from his former state and attitude and become a good and new person. . . . For our Lord Jesus Christ came for this reason, to change and transform and renew human nature and to recreate this soul that had been overturned by passions through the transgression. He came to mingle human nature with his own Spirit of the Godhead. A new mind and a new soul and new eyes, new ears, a new spiritual tongue, and, in a word, new humans—this was what he came to effect in those who believe in him.

—Pseudo-Macarius

WITHDRAWAL TO PRAY

Yet [Jesus] went apart alone to the mountain to pray. He gave an example of withdrawal, to teach us that if we want to address God with a heart of integrity we should go apart from all crowd and tumult that disturbs our peace; and there, . . . we may in part succeed in attaining at least the shadow of the bliss promised to the saints in the future, and God may be to us all in all.

Then our Saviour's prayer, wherein he prayed the Father for his disciples, will be truly fulfilled in us: "that the love wherein thou lovedst me may be in them, and they in us": and "that they all may be one, as thou, Father, art in me and I in thee, that they also may be one in us." This unity will be when that perfect love of God, wherewith "he first loved us" has passed into the affections of our own hearts. So his prayer will be fulfilled, and we believe that that prayer cannot fail of its effect.

—Cassian

BECOMING ONE WITH CHRIST

As when one wax is melted into another, so, I think, he who receives the body of our Saviour Christ and drinks his precious blood as He Himself has said, becomes one with Him by this participation, so that he finds himself in Christ and Christ finds Himself in him. . . .

—Cyril of Alexandria

CHRIST BE WITH ME

I bind unto myself this day
The strong name of the Trinity
By invocation of the same,
The Three in One, and One in Three.
I bind this day to me forever
By power of faith, Christ's incarnation,
His baptism in Jordan river,
His death on cross for my salvation.
His bursting from the spicèd tomb,
His riding up the heavenly way,
His coming at the day of doom,
I bind unto myself this day.
I bind unto myself the power
Of the great love of Cherubim,
The sweet "well done" in judgment hour,
The service of the Seraphim.
Confessor's faith, Apostle's word,
The Patriarch's prayers, the Prophet's scrolls,
All good deeds done unto the Lord,
And purity of virgin souls.
Christ be with me, Christ within me,
Christ behind me, Christ before me,
Christ beside me, Christ to win me,

FIFTH CENTURY

Christ to comfort and restore me,
Christ beneath me, Christ above me,
Christ in quiet, Christ in danger,
Christ in hearts of all that love me,
Christ in mouth of friend and stranger.

—Patrick

THE TWO NATURES OF CHRIST

*T*herefore, following the holy Fathers, we all with one accord teach men to acknowledge one and the same Son, our Lord Jesus Christ, at once complete in Godhead and complete in manhood, truly God and truly man, consisting also of a reasonable soul and body; of one substance with the Father as regards his Godhead, and at the same time of one substance with us as regards his manhood; like us in all respects, apart from sin; as regards his Godhead, begotten of the Father before the ages, but yet as regards his manhood begotten, for us men and for our salvation, of Mary the Virgin, the God-bearer; one and the same Christ, Son, Lord, Only-begotten, recognized IN TWO NATURES, WITHOUT CONFUSION, WITHOUT CHANGE, WITHOUT DIVISION, WITHOUT SEPARATION; the distinction of natures being in no way annulled by the union, but rather the characteristics of each nature being preserved and coming together to form one person and subsistence, not as parted or separated into two persons, but one and the same Son and Only-begotten God the Word, Lord Jesus Christ; even as the prophets from earliest times spoke of him, and our Lord Jesus Christ himself taught us, and the creed of the Fathers has handed down to us.

—The Council of Chalcedon

SIXTH CENTURY

~~~~~~~~~~~~~~~~~~~~~~~~~~~~~

## THE MEEKNESS OF OUR LORD

$\mathscr{L}$isten to what the Lord says: "Learn of me; for I am meek and lowly in heart: and ye shall find rest unto your souls" (Mt. 11:29). He shows here the root and cause of all ills and their cure, the cause of all good, namely, that self-exaltation has brought us down and that pardon cannot be obtained except through its opposite, humility.

—Dorotheus

## THE LOVE LIGHT OF CHRIST

$O$ Lord, give us, we beseech Thee,
In the Name of Jesus Christ Thy Son our Lord,
That love which can never cease,
That will kindle our lamps but not extinguish them,
That they may burn in us and enlighten others.

Do Thou O Christ, our dearest Saviour,
Thyself kindle our lamps,
That they may evermore shine in Thy temple
And receive unquenchable light from Thee
That will enlighten our darkness
And lessen the darkness of the world.

—Columba

# SEVENTH CENTURY

### THE HOLINESS OF CHRIST'S FACE

*L*et the heart of them that seek the Lord rejoice. Seek ye the Lord" . . . "and be strengthened; seek his face continually" (Ps. 105:3, 4)—be sanctified by the holiness of His countenance and be cleansed of your sins.

—Isaac of Syria

### CHRIST COMES IN DIFFERENT FORMS

*F*or the Lord does not always appear in glory to those who are standing before him; rather, he comes in the form of a servant to beginners, and to those who are strong enough to follow him in climbing the lofty mountain of his transfiguration before the creation of the world. Thus it is possible for the Lord not to appear in the same form to all those who meet him, but to some in one way and to others in another way, that is, by varying the contemplation according to the measure of faith in each one.

—Maximus the Confessor

### HE DRIVES AWAY THE DARKNESS

*T*he Lord is called light and life and resurrection and truth. He is light as the brightness of souls and as the one who drives away the darkness of ignorance, as the one who enlightens the mind to understand unutterable things, and as the one who reveals mysteries which can be perceived only by the pure. He is life as

the one who grants to souls who love the Lord the movement proper for divine things. Again, he is resurrection as the one who raises up the mind from a deathly craving for material things and cleanses it from all kinds of corruption and death. Finally, he is truth as the one who gives to those who are worthy an inflexible disposition toward the good.

—Maximus the Confessor

## BECOMING ACCUSTOMED TO THE LIGHT

The light of dawn comes before the sun, and meekness is the precursor of all humility. So let us listen to the order in which Christ, our Light, places these virtues. He says: "Learn from Me, because I am meek and humble of heart" (Mt. 11:29). Therefore before gazing at the sun of humility we must let the light of meekness flow over us. If we do, we will then be able to look steadily at the sun. The true order of these virtues teaches us that we are totally unable to turn our eyes to the sun before we have first become accustomed to the light.

—John Climacus

# EIGHTH CENTURY

~~~~~~~~~~~~~~~~~~~~~~~~~~~~

NOT BY FORCE, BUT BY GENTLENESS

𝒯he Gospel of the knowledge of God has been preached to the whole world and has put the adversaries to flight not by war and arms and camps. Rather, it was a few unarmed, poor, unlettered, persecuted, tormented, done-to-death men, who, by preaching One who had died crucified in the flesh, prevailed over the wise and powerful, because the almighty power of the Crucified was with them. That death which was once so terrible has been defeated and He who was once despised and hated is now preferred before life. These are the successes consequent upon the advent of the Christ; these are the signs of His power. For it was not as when through Moses He divided the sea and brought one people safely through out of Egypt and the bondage of Pharaoh. Rather, He delivered all humanity from death's destruction and the tyrant that was sin. It was not by force that He led sinners to virtue, not by having them swallowed up by the earth, nor by having them burnt up by fire, nor by ordering them stoned to death; it was with gentleness and forbearance that He persuaded men to choose virtue and for virtue's sake to undergo sufferings with rejoicing. Sinners were formerly tormented, yet they clung to their sin, and sin was accounted a god by them; but now, for piety and virtue's sake, they choose torments, tortures, and death.

Well done, O Christ, O Wisdom and Power and Word of God, and God almighty! What should we

resourceless people give Thee in return for all things? For all things are Thine and Thou askest nothing of us but that we be saved. Even this Thou hast given us, and by Thy ineffable goodness Thou art grateful to those who accept it. Thanks be to Thee who hast given being and the grace of well-being and who by Thy ineffable condescension hast brought back to this state those who fell from it.

—John of Damascus

NINTH CENTURY

~~~~~~~~~~~~~~~~~~~~~~~~~~~~~~~~~

### THE NEARNESS OF CHRIST

Seek the Lord while he can be found: call upon him while he is near." How near indeed he is! "For in him we live and are moved and have our being." He is deep in all minds, around all bodies; he fills up within, surrounds without, bears up below, covers above. But the time will come when he who is now so near cannot be found. Why will he not be found who is everywhere and who is nowhere absent? Because there will not be time for seeking the Lord, but only for suffering of punishments by those who do not find him now. Do what the psalmist says, "Let all thy works give thanks to thee, O Lord, and let all thy saints bless thee." Bless him with them and give thanks to the Lord with all his works.

It is not needful for you to wander from place to place, from this kingdom to another, to seek the Lord. Offering himself to you freely, he says, "Behold, I stand at the door and knock; if anyone hears my voice and opens the door, I will come in to him and eat with him, and he with me."

—Agobard of Lyons

# CELEBRATION OF THE BIRTHDAY

If an earthly king or the head of some great family should invite you to his birthday party, what kind of dress would you be anxious to wear when you go, how new, how neat, how elegant, so that the eye of your host would take no offense from its age, its shabbiness, or its dirtiness. Therefore, in this same way, strive zealously, as far as you can, Christ being your helper, that your souls may be decorated by the various ornaments of virtues, decked out with the gems of simplicity and the flowers of sobriety, with clear conscience, when they go to the birthday celebrations of the Eternal, that is, of the Lord our Saviour. Let them gleam with purity, shine in love, be bright with acts of charity, glow with righteousness and humility, dazzle, before all else, with love of God.

For the Lord Christ, should he see you so dressed celebrating his birthday, will himself deign to come himself, and not only to visit your souls but even to remain there and to dwell in them, as it is written: "Because, see, I will come and I shall live and move among them and they shall be my people, and I shall be their God," says the Lord God. O how happy is that soul which is brought by good works to receive Christ as guest and indweller, ever happy, ever joyful, ever glad, and free from every dread of vices!

—Rabanus Maurus of Mainz

# O COME, O COME, EMMANUEL

*O* come, O come, Emmanuel, and ransom captive
        Israel,
That mourns in lonely exile here until the Son of God
        appear.
Rejoice! Rejoice! Emmanuel shall come to thee, O
        Israel.

O come, O come, great Lord of might, who to thy
        tribes on Sinai's height
In ancient times once gave the law in cloud and
        majesty and awe.
Rejoice! Rejoice! Emmanuel shall come to thee, O
        Israel.

O come, thou Key of David, come, and open wide
        our heavenly home.
Disperse the gloomy clouds of night, and death's dark
        shadows put to flight.
Rejoice! Rejoice! Emmanuel shall come to thee, O
        Israel.

—Anonymous (Latin)

# TENTH CENTURY

## CHRIST, MIGHTY SAVIOR

Christ, mighty Savior, Light of all creation,
You make the daytime radiant with the sunlight
And to the night give glittering adornment,
Stars in the heavens.

Now comes the day's end as the sun is setting,
Mirror of daybreak, pledge of resurrection;
While in the heavens choirs of stars appearing
Hallow the night fall.

Therefore we come now evening rites to offer,
Joyfully chanting holy hymns to praise you,
With all creation joining hearts and voices
Singing your glory.

Give heed, we pray you, to our supplication,
That you may grant us pardon for offenses,
Strength for our weak hearts, rest for aching bodies,
Soothing the weary.

Though bodies slumber, hearts shall keep their vigil,
Forever resting in the peace of Jesus,
In light or darkness worshiping our Savior
Now and forever.

—Mozarabic Hymn

# ELEVENTH CENTURY

~~~~~~~~~~~~~~~~~~~~~~~~~~~~~~~~~~~

SOURCE OF ALL BEAUTY

I have a word in secret with Thee my Lord, King of Ages, Christ Jesus. . . .

Thou hast clothed the sun with a splendour pre-eminent among the stars, and brighter than the sun art Thou. Nay, what is the sun, what all created light, but darkness in comparison of Thee? Thou hast furnished forth the heaven with stars, the empyrean with angels, the air with birds, the waters with fishes, the earth with herbs, the thickets with flowers. But there is no form or fairness in any of these that can compare with Thee, O source of all beauty, Lord Jesus!

—Anselm of Canterbury

THE SEAL OF CHRIST

*W*hy do we not give up our souls to death for Christ our God who has died for us? Why are we fearful and why do we dread our departure from the body? Surely hell is not about to receive or take possession of the souls of those who have hoped in Christ. Can death have any power over the souls that have been sealed by the grace of the all-Holy Spirit and the Blood of Christ? Dare the spiritual wolf look straight at the seal of Christ "the Chief Shepherd" (1 Pet. 5:4), which He places on His own sheep? By no means, faithful brethren of godly mind! Therefore, as many as lack the seal, run to Him! All who have not been signed, hasten to be marked with the sign of the Spirit! But

who is he who lacks the seal? He who is frightened of death. Who lacks the sign? He who does not know for sure the form of the sign. For he who has learned of the divine imprint is bold in faith and has acquired hope that cannot be put to shame. Wherefore let us seek Christ, with whom we have been clothed through Holy Baptism (Gal. 3:27).

—Symeon the New Theologian

TWELFTH CENTURY

SPIRITUAL FRIENDSHIP

For what more sublime can be said of friendship, what more true, what more profitable, than that it ought to, and is proved to, begin in Christ, continue in Christ, and be perfected in Christ?

—Aelred of Rievaulx

"YOU ARE MY FRIENDS"

Whence it is that the Lord in the Gospel says: "I will not now call you servants but friends"; and then adding the reason for which they are considered worthy of the name of friend: "because all things, whatsoever I have heard of my Father, I have made known to you." And in another place: "You are my friends, if you do the things that I command you." From these words, as Saint Ambrose says, "He gives the formula of friendship for us to follow: namely, that we do the will of our friend, that we disclose to our friend whatever confidences we have in our hearts, and that we be not ignorant of his confidences. Let us lay bare to him our heart and let him disclose his to us. For a friend hides nothing. If he is true, he pours forth his soul just as the Lord Jesus poured forth the mysteries of the Father."

—Aelred of Rievaulx

WHAT DOES THE CROSS MEAN?

The force of habit has inured us to the sight of you upon the cross, to the thought of you as dead and buried and—what should pierce our hearts even more readily and deeply—to the thought of you who on the cross thirsted for nothing but our salvation, as buffeted and scourged, as mocked and spit upon, pierced by the nails and spear, crowned with the thorns, and given gall or vinegar to drink. The earth trembled when you were crucified; we laugh. The heavens and its lights were darkened; we want to shine before the world. The rocks were rent; but we harden our hearts. The opened graves gave up their dead; but we, taking our ease on the bed of self-indulgence, bury our dead.

—William of St. Thierry

THE SPEAR WOUND IN JESUS' SIDE

Those unsearchable riches of your glory, Lord, were hidden in your secret place in heaven until the soldier's spear opened the side of your Son our Lord and Savior on the cross, and from it flowed the mysteries of our redemption. Now we may not only thrust our finger or our hand into his side, like Thomas, but through that open door may enter whole, O Jesus, even into your heart, the sure seat of your mercy, even into your holy soul that is filled with the fullness of God, full of grace and truth, full of our salvation and our consolation.

Open, O Lord, the ark-door of your side, that all your own who shall be saved may enter in, before this flood that overwhelms the earth. Open to us your body's side, that those who long to see the secrets of your Son may enter in, and may receive the sacraments

that flow therefrom, even the price of their redemption. Open the door of your heaven, that your redeemed may see the good things of God in the land of the living, though they still labor in the land of the dying. Let them see and long, and yearn and run; for you have become the way by which they go, the truth to which they go, the life for which they go. The way is the example of your lowliness; the truth the pattern of your purity; the life is eternal life.

—William of St. Thierry

HOW HE LOVED US

*B*ut there is a fact which moves, and excites, and fires me much more than this. Above all things, it is the cup which thou didst drink, O Jesu, merciful and kind, the great task of our redemption undertaken by thee, which is a stronger motive than any other for love to thee. It is this which easily draws to itself all the love I have to give, which attracts my affection more sweetly, which requires it more justly, which retains it by closer ties and a more vehement force. To this end the Saviour endured many and great things, nor in the making of the whole world did its Creator take upon himself a task so laborious. For in that earlier work *he spake, and it was done: he commanded, and it stood fast.* But in the later one he had to bear with [persons] who contradicted his words, met his actions with ill-natured criticism, insulted his sufferings and even revived his death. Behold, then, how he loved us!

—Bernard of Clairvaux

JESUS, THE VERY THOUGHT OF THEE

Jesus, the very thought of thee
With sweetness fills the breast;
But sweeter far thy face to see,
And in thy presence rest.

O hope of every contrite heart,
O joy of all the meek,
To those who fall, how kind thou art!
How good to those who seek!

But what to those who find?
Ah, this nor tongue nor pen can show;
The love of Jesus, what it is,
None but his loved ones know.

Jesus, our only joy be thou,
As thou our prize will be;
Jesus, be thou our glory now,
And through eternity.

—Bernard of Clairvaux

THIRTEENTH CENTURY

~~~~~~~~~~~~~~~~~~~~~~~~~

### WITH CHRIST I DIE, WITH CHRIST I LIVE

*D*raw near, O handmaid, with loving steps to Jesus wounded for you, to Jesus crowned with thorns, to Jesus nailed to the gibbet of the Cross. Gaze with the Blessed Apostle St. Thomas, not merely on the print of the nails in Christ's hands; be not satisfied with putting your finger into the holes made by the nails in His hands; neither let it be sufficient to put your hand into the wound in His side; but enter bodily by the door in His side and go straight up to the very Heart of Jesus. There, burning with love for Christ Crucified, be transformed into Christ. Fastened to the Cross by the nails of the fear of God, transfixed by the lance of the love of your inmost heart, pierced through and through by the sword of the tenderest compassion, seek for nothing else, wish for nothing else, look for consolation in nothing else except in dying with Christ on the Cross. Then, at last, will you cry out with Paul the Apostle: "With Christ I am nailed to the Cross. I live, yet not I; but Christ liveth in me" (Gal. 2:20).

—Bonaventura

# HOW OUR LORD WAS SEEN
## LOOKING LIKE A WORKER

Our Lord showed me an allegory that he realized in me and still does. I saw a poor man get up from the ground. He was clothed in poor linen cloth like a worker. In his hands he had a carrying frame. On it lay a burden similar to the earth. I said: "My good man, what are you carrying?"

"I am carrying," he said, "your sufferings. Turn your will toward suffering; lift, and carry."

And the person said: "Lord, I am so poor that I do not have anything."

Our Lord said: "This is what I taught my disciples when I said: 'Blessed are the poor in spirit.' This is the case when a person can do nothing but would like to—that is spiritual poverty."

The person: "Lord, if it is you, turn your face toward me so that I can recognize you."

And our Lord said: "Recognize me within."

The soul: "Lord, if I were to see you in the midst of thousands, I would easily recognize you." My heart turned me within into a guard and I did not dare dispute with him that it was he. So I said: "Dear Lord, this burden is too heavy."

And our Lord said: "I shall put it so close to me that you can carry it quite well. Follow me and see how I stood on the cross in the sight of my heavenly Father, and remain like that."

She said: "Lord, give me your blessing for it."

"I bless you without ceasing. There will be good help for your sufferings."

"Lord, help in this all those who willingly suffer torment for love of you."

—Mechthild of Magdeburg

# HOW ONE SHOULD THANK THE SON

It is well for me to thank you, imperial Son of God. I shall thank you always that you took me, in the world, out of the world. Your holy pain that you suffered for my sake is mine. All that I ever suffer I want to give to you in return. Even though this is an unequal bargain, it nevertheless makes my soul free. Keep me always in your favor, so that you may be praised forever. Jesus, my dearly Beloved, loosen my bonds; let me remain with you.

—Mechthild of Magdeburg

# FOURTEENTH CENTURY

## CONFORM MY WILL TO YOURS

*O*h my Lord, my God, my Creator and Redeemer, I unworthy sinner beseech You, through this Your great and admirable work of mercy—the transformation of the bread into Your true body and the transformation of the wine and the water into Your blood for the sake of our eternal and most wholesome comfort—that You might completely conform my will to Your whole will, that I always, my entire life, am able to do all that is pleasing to You, in thought, word and active deed. Amen.

—Birgitta

## OUR MOTHER, JESUS

*H*e could not die any more, but he did not want to cease working; therefore he must needs nourish us, for the precious love of motherhood has made him our debtor.

The mother can give her child to suck of her milk, but our precious Mother Jesus can feed us with himself, and does, most courteously and most tenderly, with the blessed sacrament, which is the precious food of true life; and with all the sweet sacraments he sustains us most mercifully and graciously, and so he meant in these blessed words, where he said: I am he whom Holy Church preaches and teaches to you. That is to say: All the health and the life of the sacraments, all the power and the grace of my word, all the goodness which is ordained in Holy Church for you, I am he.

The mother can lay her child tenderly to her breast, but our tender Mother Jesus can lead us easily into his blessed breast through his sweet open side, and show us there a part of the godhead and of the joys of heaven, with inner certainty of endless bliss.

—Julian of Norwich

## ENFOLDED IN HIS LOVE

At the same time as I saw this sight of the head bleeding, our good Lord showed a spiritual sight of his familiar love. I saw that he is to us everything which is good and comforting for our help. He is our clothing, who wraps and enfolds us for love, embraces and shelters us, surrounds us for his love, which is so tender that he may never desert us.

—Julian of Norwich

## YOU WILL NOT BE OVERCOME

[Christ] did not say: You will not be troubled, you will not be belaboured, you will not be disquieted; but he said: You will not be overcome.

—Julian of Norwich

## HE IS WITH US

Christ alone performed all the great works which belong to our salvation, and no one but he; and just so, he alone acts now in the last end, that is to say he dwells here in us, and rules us, and cares for us in this life, and brings us to his bliss.

—Julian of Norwich

# CHRIST IS THE BRIDGE

[Catherine writes what she has heard God saying.]
So I gave you a bridge, my Son, so that you could cross over the river, the stormy sea of this darksome life, without being drowned.

See how indebted to me my creatures are! And how foolish to choose to drown rather than accept the remedy I have given!

Open your mind's eye and you will see the blinded and the foolish, the imperfect, and the perfect ones who follow me in truth. Then weep for the damnation of the foolish and be glad for the perfection of my beloved children. Again, you will see the way of those who choose light and the way of those who choose darkness.

But first I want you to look at the bridge of my only-begotten Son, and notice its greatness. Look! It stretches from heaven to earth, joining the earth of your humanity with the greatness of the Godhead. This is what I mean when I say it stretches from heaven to earth—through my union with humanity.

This was necessary if I wanted to remake the road that had been broken up, so that you might pass over the bitterness of the world and reach life. From earth alone I could not have made it great enough to cross the river and bring you to eternal life. The earth of human nature by itself, as I have told you, was incapable of atoning for sin and draining off the pus from Adam's sin, for that stinking pus had infected the whole human race. Your nature had to be joined with the height of mine, the eternal Godhead, before it could make atonement for all of humanity. Then human nature could endure the suffering, and the divine nature, joined with that humanity, would

accept my Son's sacrifice on your behalf to release you from death and give you life.

. . . But my Son's having made of himself a bridge for you could not bring you to life unless you make your way along that bridge.

—Catherine of Siena

## THE SHINING STONE

*A*nd therefore the Spirit of our Lord speaks thus in the Book of the Secrets of God, which Saint John wrote down [Rev. 2:17]: "To him that overcometh," he says, that is, to him who overcometh and conquereth himself and all else, "will I give to eat of the hidden manna," that is, an inward and hidden savor and celestial joy; "and will give him a sparkling stone, and in the stone a new name written, which no man knoweth saving he that receiveth it." This stone is called a pebble, for it is so small that it does not hurt when one treads on it. This stone is shining white and red like a flame of fire; and it is small and round, and smooth all over, and very light. By this sparkling stone we mean our Lord Christ Jesus, for he is, according to his Godhead, a shining forth of the eternal Light, and an irradiation of the glory of God, and a flawless mirror in which all things live. Now to him who overcomes and transcends all things, this sparkling stone is given; and with it he receives light and truth and life. This stone is also like to a fiery flame, for the fiery love of the Eternal Word has filled the whole world with love and wills that all loving spirits be burned up to nothingness in love. This stone is also so small that a man hardly feels it, even though he treads it underfoot. And that is why it is called *calculus*, that is, "treadling." And this is made clear to us by Saint Paul,

where he says that the Son of God "emptied himself, and humbled himself, and took upon him the form of a servant, and became obedient unto death, even the death of the cross." And he himself spoke through the mouth of the prophet, saying: "I am a worm, and no man; a reproach of men, and despised of the people." And he made himself so small in time that the Jews trod him under their feet. But they felt him not; for, had they recognized the Son of God, they had not dared to crucify him. He is still little and despised in all men's hearts that do not love him well. This noble stone of which I speak is wholly round and smooth and even all over. That the stone is round teaches us that the divine Truth has neither beginning nor end; that it is smooth and even all over teaches us that the divine Truth shall weigh all things evenly, and shall give to each according to his merits; and that which he gives shall be with each throughout eternity.

—Jan van Ruysbroeck

## KNITTED TO CHRIST BY LOVE

Help me now for the love of Jesus. This, "for the love of Jesus," is very well said. For there in the love of Jesus is your help. Love is so powerful that it makes everything ordinary. So love Jesus, and everything that he has is yours. By his Godhead he is the maker and giver of time. By his manhood he is truly the keeper of time. And by his Godhead and manhood together he is the truest judge and accountant of the spending of time. Knit yourself, then, to him by love and by faith. And in virtue of that knot you shall be a regular partner with him and with all who are so well fastened to him by love.

—*The Cloud of Unknowing*

## JESUS IS FOUND IN POVERTY

$\mathcal{I}$ went about by covetousness of riches, and I found not Jesus. I ran by the wantonness of the flesh, and I found not Jesus. I sat in companies of worldly mirth and I found not Jesus. In all of them . . . I found Him not; for He let me know by His grace that He is not found in the land of softly living. Therefore, I turned by another way, and I ran about by poverty, and I found Jesus, poorly born into the world, laid in a crib, lapped in cloths. I went by sharpness of suffering; and I found Jesus weary in the way tormented with hunger, thirst and cold, filled with reproofs and blame. I sat by my love . . . and I found Jesus, in the desert, fasting, in the Mount, praying alone. I ran by pain and penance, and I found Jesus, bound, scourged, given gall to drink, nailed to the Cross . . . and dying on the Cross. Therefore, Jesus is not found in riches but in poverty . . . not among many but in loneliness. If thou wilt be well with God, and have grace to rule thy life right and come to the joy of love: fasten this Name of Jesus so fast in thine heart that it can never come out of thy thought.

—Richard Rolle

# THE CHRIST LIFE

*H*e who grasps and knows what the Christ life is also grasps and knows Christ himself. Conversely, he who does not know what this life is does not know Christ. He who believes in Christ also believes that the Christ life is the noblest and best.

He who does not believe this does not believe in Christ. As much Christ life as there is in a person, that much of Christ there is also in him; and as little of the one, as little of the other. For where the Christ life is, Christ is also present. Where this life is not, Christ is not.

In the Christ life one speaks with Saint Paul, who writes: I live, yet not I, but Christ lives in me. This is life at its noblest and best. For where that life is, God Himself is and lives, with all goodness. How could there be a better life?

We speak of obedience, of a new man, of true Light, of true Love, and of the Christ life, yet it all means the same. Where one of these parts of true Life is, they all are. Where one of them breaks down or is absent, none of them can be present. For they are all of one piece in the realm of truth and being.

You should cling only to that by which you will obtain this life—and to nothing else—so that it may be born and come alive within you. Everything that leads away from it, abandon that, shun it.

—*Theologia Germanica*

# FIFTEENTH CENTURY

~~~~~~~~~~~~~~~~~~~~~~~~~~~~

LET ME SPEAK TO YOU

\mathcal{D}aughter, thou mayst no better please God than to think continually in His love."

Then she asked our Lord Jesu Christ, how she should best love Him. And our Lord said . . . "Think on my goodness."

"Daughter, if thou wear the habergeon or the hairshirt, fasting bread and water, and if thou saidest every day a thousand Pater Nosters, thou shalt not please Me so well as thou dost when thou art in silence, and suffrest Me to speak in thy soul. . . ."

Our Lord said to her: "In nothing that thou dost or sayest, daughter, thou mayst no better please God than believe that He loveth thee. For, if it were possible that I might weep with thee, I would weep with thee for the compassion that I have of thee. . . ."

"Lord," she said, "for Thy great pain have mercy on my little pain."

—Margery Kempe

FINITE AND INFINITE

\mathcal{O} Jesu, thou end of the universe, in whom resteth, as in the final degree of perfection, every creature, thou art utterly unknown to the wise of this world. For of thee we affirm many antitheses that are yet most true, since thou art alike Creator and creature, alike he that attracteth and he that is attracted, alike finite and infinite. They pronounce it folly to believe this possible, and because of it they flee from thy name, and do not

receive thy light whereby thou hast illumined us. But, esteeming themselves wise, they remain forever foolish, and ignorant, and blind. Yet if they would believe that thou art Christ, God and Man, and would receive and handle the words of the gospel as being those of so great a Master, then at last they would see most clearly that, in comparison with that light there hidden in the simplicity of thy words, all things else are nought but thickest shadows, and ignorance. Thus 'tis only humble believers who attain unto this most gracious and life-giving revelation. There is hidden in thy most holy gospel, which is heavenly food, as there was in the manna, sweetness to satisfy all desire, which can only be tasted by him that believeth and eateth. If any believeth and receiveth it, he shall prove and find the truth, because thou didst come down from heaven and thou alone art the Master of truth.

—Nicholas of Cusa

FRIENDSHIP WITH JESUS

*W*hen Jesus is present, all is well and nothing seems difficult; but when Jesus is absent, everything is hard.

When Jesus speaketh not within, consolation is little worth; but if Jesus speak only one word, we feel great consolation.

Did not Mary Magdalene instantly rise up from the place where she wept when Martha said to her: "The Master is come, and calleth for thee"?

Happy hour, when Jesus calleth thee from tears to joy of spirit.

How dry and hard art thou without Jesus! How foolish and vain, if thou desire anything out of Jesus!

Is not this a greater loss to thee than if thou shouldst lose the whole world?

What can the world give thee without Jesus?

To be without Jesus is a grievous hell; to be with Jesus a sweet paradise.

If Jesus be with thee, no foe can harm thee.

Whoever findeth Jesus findeth a good treasure—yea, a good above every good.

And he that loseth Jesus loseth much—yea, more than the whole world.

He that liveth without Jesus is in wretched poverty; and he who is with Jesus, is most rich.

—Thomas à Kempis

OF THE SMALL NUMBER OF THE LOVERS OF THE CROSS OF JESUS

Jesus hath now many lovers of His heavenly kingdom, but few bearers of His cross.

He hath many that are desirous of consolation, but few of tribulation.

He finds many companions of His table, but few of his abstinence.

All desire to rejoice with Him, but few are willing to endure anything for His sake.

Many follow Jesus to the breaking of bread, but few to the drinking of the chalice of His Passion.

Many reverence His miracles, but few follow the ignominy of His Cross.

Many love Jesus as long as they meet with no adversity; many praise Him and bless Him as long as they receive some consolations from Him.

But if Jesus hid Himself, and leave them for a little while, they either murmur or fall into excessive dejection.

—Thomas à Kempis

SIXTEENTH CENTURY

CHRIST, THE WORD OF GOD

*O*ne thing, and one alone, is necessary for life, justification, and Christian liberty; and that is the most holy word of God, the Gospel of Christ, as He says, "I am the resurrection and the life; he that believeth in Me shall not die eternally" (Jn. 11:25), and also, "If the Son shall make you free, you shall be free indeed" (Jn. 8:36), and "Man shall not live by bread alone, but by every word that proceedeth out of the mouth of God" (Mt. 4:4). . . .

But you will ask, What is this word, and by what means is it to be used, since there are so many words of God? I answer, The Apostle Paul (Rom. 1) explains what it is, namely the Gospel of God, concerning His Son, incarnate, suffering, risen, and glorified, through the Spirit, the Sanctifier. To preach Christ is to feed the soul, to justify it, to set it free, and to save it, if it believes the preaching. For faith alone and the efficacious use of the word of God, bring salvation. "If thou shalt confess with thy mouth the Lord Jesus, and shalt believe in thine heart that God hath raised Him from the dead, thou shalt be saved" (Rom. 10:9); and again, "Christ is the end of the law for righteousness to every one that believeth" (Rom. 10:4), and "The just shall live by faith" (Rom. 1:17). For the word of God cannot be received and honoured by any works, but by faith alone. Hence it is clear that as the soul needs the word alone for life and justification, so it is justified by faith alone, and not by any works.

—Martin Luther

THE MARRIAGE OF CHRIST TO THE SOUL

The third incomparable grace of faith is this: that it unites the soul to Christ, as the wife to the husband, by which mystery, as the Apostle teaches, Christ and the soul are made one flesh. Now if they are one flesh, and if a true marriage—nay, by far the most perfect of all marriages—is accomplished between them (for human marriages are but feeble types of this one great marriage), then it follows that all they have becomes theirs in common, as well good things as evil things; so that whatsoever Christ possesses, that the believing soul may take to itself and boast of as its own, and whatever belongs to the soul, that Christ claims as His.

If we compare these possessions, we shall see how inestimable is the gain. Christ is full of grace, life, and salvation; the soul is full of sin, death, and condemnation. Let faith step in, and then sin, death, and hell will belong to Christ, and grace, life, and salvation to the soul.

—Martin Luther

RUN DIRECTLY TO THE MANGER

This is why Paul makes such a frequent practice of linking Jesus Christ with God the Father, to teach us what is the true Christian religion. It does not begin at the top, as all other religions do; it begins at the bottom. It bids us climb up by Jacob's ladder; God Himself leans on it, and its feet touch the earth, right by Jacob's head (Gen. 28:12). Therefore whenever you are concerned to think and act about your salvation, you must put away all speculations about the Majesty, all thoughts of works, traditions, and philosophy— indeed, of the Law of God itself. And you must run directly to the manger and the mother's womb, em-

brace this Infant and Virgin's Child in your arms, and look at Him—born, being nursed, growing up, going about in human society, teaching, dying, rising again, ascending above all the heavens, and having authority over all things. In this way you can shake off all terrors and errors, as the sun dispels the clouds. This vision will keep you on the proper way, so that you may follow where Christ has gone. When Paul wishes grace and peace not only from God the Father but also from Jesus Christ, therefore, this is what should be noted first.

<div align="right">—Martin Luther</div>

WE ARE TOO WEAK

We are indeed too weak to knock the Devil with his character down. That must Christ Jesus, the Son of God, do. Thus we are too little to bring ourselves into the friendship of God. That must someone else do, one who is better known than we. Yes, that also is Christ. We are too weak to be able to deserve from God, in our own power, that He should be bound to give us His Kingdom and the eternal blessedness. It is too splendid for us to deserve.

<div align="right">—Olaus Petri</div>

HERE IS MY LIFE

First strengthen my soul, and prepare it, O Jesus, my supreme Good, and then ordain the means whereby I may do something for You. No one could bear to receive so much and pay nothing in return. Cost what it may, O Lord, I pray You not to let me appear before You so empty-handed. . . . Here is my life; here is my honour; here is my will; I have given them all to You; I am Yours; do with me what You will. I know very well,

my Lord, how little I can do. But now that I have come to You, now that I have climbed that watch-tower from which all truth can be seen, I shall be capable of all things so long as You do not depart from me. But if You depart from me, even for a moment, I shall fall back to where I was; which was in hell.

—Teresa of Avila

CHRIST IMPRINTS HIS LOVE ON US

\mathcal{I} will conclude then by saying that whenever we think of Christ, we should remember the love with which He has bestowed all these favours on us, and what great love our Lord God has revealed to us also in giving us this pledge of His love for us, for love calls out love. So, although we may be very much at the beginning and very wicked, let us try always to think of this and to arouse love in ourselves. For if once the Lord grants us the favour of imprinting this love on our hearts, everything will be easy for us, and we shall do great things in a very short time and with very little labour. May His Majesty grant us this love, since He knows how much we need it, for the sake of that love which He bore us and for His glorious Son, who revealed it to us at such great cost to Himself. Amen.

—Teresa of Avila

HOW LITTLE DO WE KNOW THEE

\mathcal{O}h my Lord and my God! how wonderful is Thy greatness! yet here we live, like so many silly swains, imagining that we have attained some knowledge of Thee; and yet it is indeed a mere *nothing*, for even in ourselves there are great secrets, which we do not understand.

In this kind of vision, He clearly shows her His most sacred humanity, either as He appeared when He was in the world, or as He was after His resurrection. And though this vision takes place with a quickness, which resembles that of a flash of lightning; yet this glorious image remains so fixed in the imagination, that I consider it impossible ever to blot it out, till she behold it there where she shall possess it for ever.

Its lustre is, as it were, a transfused light, like that of the sun, covered with a something as beautiful and bright as a diamond. His garment seems like the finest holland. Almost every time that God bestows this favour on the soul, she remains in an ecstasy—her baseness and unworthiness not being able to bear so terrible a sight. I call it "terrible," because though it be the most beautiful and delightful that can be imagined, yet the presence of so great a Majesty causes such fear in the soul, that there is no need of her asking, nor of any one telling her, who He is. He clearly makes Himself known to be the Lord of heaven and earth. Oh dearest Lord! how little do we Christians know Thee!

—Teresa of Avila

UNDESERVED LOVE FOR ALL

𝓛et us here deep consider the love of our Savior Christ, which so loved His unto the end, that for their sakes He willingly suffered that painful end, and therein declared the highest point of love that can be. For as Himself saith: "A greater love no man hath than to give his life for his friends." This is indeed the greatest love that ever any other man had. But yet had our Savior a greater. For He gave His, and I said before, both for friend and foe. . . .

SIXTEENTH CENTURY

O my sweet Savior Christ, which, of Thine unde-
served love toward mankind so kindly wouldest suffer
the painful death of the cross, suffer not me to be cold
nor lukewarm in love again toward Thee.

—Thomas More

NO MORE TO SAY

*B*ut now that the faith is established through Christ,
and the gospel law made manifest in this era of grace,
there is no reason for inquiring of Him in this way, or
expecting him to answer as before. In giving us His
Son, His only Word (for He possesses no other), He
spoke everything to us at once in this sole Word—
and He has no more to say.

This is the meaning of that passage where St. Paul
tries to persuade the Hebrews to turn from commu-
nion with God through the old ways of the Mosaic
law and instead fix their eyes on Christ: "That which
God formerly spoke to our fathers through the
prophets in many ways and manners, now, finally, in
these days He has spoken to us all at once in His son"
[Heb. 1:1-2]. The Apostle indicates that God has
become as it were mute, with no more to say, because
what He spoke before to the prophets in parts, He
has now spoken all at once by giving us the All, who
is His son.

—John of the Cross

TURN YOUR EYES TO JESUS

*G*od could reason as follows: If I have already told
you all things in My Word, My Son, and if I have no
other word, what answer or revelation can I now make
that would surpass this? Fasten your eyes on Him
alone because in Him I have spoken and revealed all

and in Him you will discover even more than you ask for and desire. You are making an appeal for locutions and revelations that are incomplete, but if you turn your eyes to Him you will find them complete. For He is My entire locution and response, vision and revelation, which I have already spoken, answered, manifested, and revealed to you by giving Him to you as a brother, companion, master, ransom, and reward. On that day when I descended on Him with my Spirit on Mount Tabor proclaiming: "This is my Beloved Son in whom I am well pleased, hear Him" [Mt. 17:5], I gave up these methods of answering and teaching and presented them to Him. Hear Him because I have no more faith to reveal or truths to manifest. If I spoke before, it was to promise Christ. If they questioned Me, their inquiries were related to their petitions and longings for Christ in whom they were to obtain every good, as is now explained in all the doctrine of the evangelists and apostles. But now those who might ask Me in that way and desire that I speak and reveal something to them would somehow be requesting Christ again and more faith, yet they would be failing in faith because Christ has already been given.

—John of the Cross

GOD WITH US

Since our iniquities, like a cloud cast between us and him, had completely estranged us from the Kingdom of Heaven [cf. Isa. 59:2], no man, unless he belonged to God, could serve as the intermediary to restore peace. But who might reach to him? Any one of Adam's children? No, like their father, all of them were terrified at the sight of God [Gen. 3:8]. One of the angels? They also had need of a head, through

whose bond they might cleave firmly and undividedly to their God [cf. Eph. 1:22; Col. 2:10]. What then? The situation would surely have been hopeless had the very majesty of God not descended to us, since it was not in our power to ascend to him. Hence, it was necessary for the Son of God to become for us "Immanuel, that is, God with us" [Isa. 7:14; Mt. 1:23] and in such a way that his divinity and our human nature might by mutual connection grow together.

—John Calvin

HE SHARES ALL WITH US

*T*hus it is that we may patiently pass through this life with its misery, hunger, cold, contempt, reproaches, and other troubles—content with this one thing: that our King will never leave us destitute, but will provide for our needs until, our warfare ended, we are called to triumph. Such is the nature of his rule, that he shares with us all that he has received from the Father. Now he arms and equips us with his power, adorns us with his beauty and magnificence, enriches us with his wealth. These benefits, then, give us the most fruitful occasion to glory, and also provide us with confidence to struggle fearlessly against the devil, sin, and death. Finally, clothed with his righteousness, we can valiantly rise above all the world's reproaches; and just as he himself freely lavishes his gifts upon us, so may we, in return, bring forth fruit to his glory.

—John Calvin

SEVENTEENTH CENTURY

~~~~~~~~~~~~~~~~~~~~~~~~~~~~

## ON THAT PLACE STOOD A CROSS

Now I saw in my dream, that the highway up which Christian was to go, was fenced on either side with a wall, and that wall was called Salvation. Up this way, therefore, did burdened Christian run, but not without great difficulty, because of the load on his back.

He ran thus till he came at a place somewhat ascending, and upon that place stood a cross, and a little below, in the bottom, a sepulchre. So I saw in my dream, that just as Christian came up with the cross, his burden loosed from off his shoulders, and fell from off his back, and began to tumble, and so continued to do, till it came to the mouth of the sepulchre, where it fell in, and I saw it no more.

Then was Christian glad and lightsome, and said, with a merry heart, "He hath given me rest by his sorrow, and life by his death." Then he stood still awhile to look and wonder; for it was very surprising to him, that the sight of the cross should thus ease him of his burden. He looked therefore, and looked again, even till the springs that were in his head sent the waters down his cheeks. Now, as he stood looking and weeping, behold three Shining Ones came to him and saluted him with "Peace be to thee." So the first said to him, "Thy sins be forgiven thee;" the second stripped him of his rags, and clothed him "with change of raiment;" the third also set a mark on his forehead, and gave him a roll with a seal upon it, which he bade

him look on as he ran, and that he should give it in at the Celestial Gate. So they went their way. Then Christian gave three leaps for joy, and went on singing. . . .

—John Bunyan

## CHRIST BRINGS LIBERTY

*It* is the will and command of God that, since the coming of his Son the Lord Jesus, a permission of the most Paganish . . . or anti-Christian consciences and worships be granted to all men in all nations and countries: and they are only to be fought against with that sword which is only, in soul matters, able to conquer: to wit, the sword of God's Spirit, the word of God.

—Roger Williams

## WE LEARN BY HIS GRACE

*But*, above all, I recommend to you mental prayer, and particularly that which has the life and passion of our Lord for its object. By making Him frequently the subject of meditation, your whole soul will be filled with Him; you will learn His ways, and frame all your actions on the model of His. He is the Light of the world, it is therefore in Him, by Him, and for Him, that we ought to be enlightened and illuminated. He is the Tree of desire, under whose shadow we ought to refresh ourselves. He is the living Well of Jacob, in which we may wash away all our stains. In fine, as little children by hearing their mothers talk, and by their childish prattle with them, learn at length to

speak their language; so we, by keeping close to our Saviour in meditation, and observing His words, actions, and affections, shall by means of His grace learn to speak, act, and will like Him.

—Francis de Sales

## THE LOVE THAT CHRIST HAS FOR US

$O$bserve, my Philothea, it is certain that the heart of our dear Jesus beheld your heart from the tree of the cross, and loved it, and by this love obtained for it all the good things you will ever have, and among them your resolutions. Yes, Philothea, we may all say with the prophet Jeremiah: *O Lord, before I had a being, thou didst behold me, and calledst me by my name*: since the divine goodness did actually prepare for us all the general and particular means of our salvation, and consequently our good resolutions. As a pregnant woman prepares the cradle, the linen, and swathing clothes, and even a nurse for the child she hopes to bring forth, although it is not yet in the world, so our Saviour, designing to bring you forth to salvation, and make you His child, prepared upon the tree of the cross all that was necessary for you, your spiritual cradle, your linen, and swathing clothes, your nurse, and all that was needed for your happiness; such are all those means, all those attractions, all those graces whereby He leads your soul, and would bring it to perfection.

—Francis de Sales

## A STILL, FLOWING RIVER

There is a river, a sweet, still, flowing river, the streams whereof will make glad thy heart. And learn but in quietness and stillness to retire to the Lord, and wait upon him; in whom thou shalt feel peace and joy, in the midst of thy troubles from the cruel and vexatious spirit of this world. So wait to know thy work and service to the Lord, in thy place and station; and the Lord make thee faithful therein, and thou wilt want neither help, support nor comfort.

Thy Friend in the truest, sincerest, and most constant love.

—Isaac Penington

## ENGRAFTED INTO CHRIST

It is not enough to hear of Christ, or read of Christ; but this is the thing, to feel him my root, my life, my foundation; and my soul engrafted into him, by him who hath power to engraft.

—Isaac Penington

## WAIT IN THE LIGHT

Wait in his power and Light, that ye may be children of the Light, by believing in the Light which is the life in Christ; that you may be grafted into him, the true root, and built upon him, the true foundation.

—George Fox

## THERE IS ONLY ONE

*I* saw there was none among them all that could speak to my condition. And when all my hopes in them and in all [people] were gone, so that I had nothing outwardly to help me, nor could tell what to do, then, Oh then, I heard a voice which said, "There is one, even Christ Jesus, that can speak to thy condition," and when I heard it my heart did leap for joy. Then the Lord did let me see why there was none upon the earth who could speak to my condition, namely, that I might give him all the glory; for all are concluded under sin, and shut up in unbelief as I had been, that Jesus Christ might have the pre-eminence, who enlightens, and give grace, and faith and power. Thus, when God doth work who shall let [prevent] it? And this I know experimentally.

—George Fox

## TENDING TO CHRIST

*A*nd where can be the danger of walking in the only true way, which is JESUS CHRIST! of giving up ourselves to Him, fixing our eye continually upon Him, placing all our confidence in His grace, and tending with all the strength of our soul to His pure love?

—Madame Guyon

## CHRIST, THE TRUE MEDICINE
## THAT RESTORES

God was pleased, in his infinite wisdom, to give us his beloved Son, in order to restore us to that life, happiness, and salvation which we had lost. Hence he has made the precious blood of Christ to be the grand restorative of our nature, and the cleanser from all the contagion of sin. He hath given us his quickening flesh, to be our bread of life; his holy wounds, as a sovereign balsam to heal our wounded condition; and his precious death, to be an abolition of our death, both temporal and eternal. . . .

CHRIST is become the true medicine of thy soul, to restore thee—thy meat and thy drink, to refresh thee—thy fountain of life, to quench thy thirst—thy light, in darkness—thy joy, in sadness—thine advocate, against thy accusers—wisdom, against thy folly—righteousness, against thy sin—sanctification, against thy unworthiness—redemption, against thy bondage—the mercy-seat, against the judgment-seat—the throne of grace, against thy condemnation—thy absolution, against thy fearful sentence—thy peace and rest, against an evil conscience—thy victory, against all thine enemies—thy champion, against all thy persecutors—the bridegroom of thy soul, against all rivals—thy mediator, against the wrath of God—thy propitiation, against all thy trespasses—thy strength, against thy weakness—thy way, against thy wandering—thy truth, against lying and vanity—thy life, against death.

—John Arndt

# EIGHTEENTH CENTURY

~~~~~~~~~~~~~~~~~~~~~~~~~~~~

JESUS SHALL REIGN

Jesus shall reign where'er the sun
Does its successive journeys run;
His kingdom spread from shore to shore,
Till moons shall wax and wane no more.

To Jesus endless prayer be made,
And endless praises crown his head;
His name like sweet perfume shall rise
With every morning sacrifice.

People and realms of every tongue
Dwell on his love with sweetest song;
And infant voices shall proclaim
Their early blessings on his name.

Blessings abound where'er he reigns;
All prisoners leap and loose their chains;
The weary find eternal rest,
And all who suffer want are blest.

—Isaac Watts

HE TEACHES HUMILITY

It is Jesus who gives us this lesson of meekness and humility: no other being could have taught it without our revolting at it. In all others we find imperfection, and our pride would not fail to take advantage of it. It was necessary that he should himself teach us; and he has condescended to teach us by his example. What

high authority is this! We have only to be silent and adore, to admire and to imitate.

The Son of God has descended upon the earth, and taken upon himself a mortal body, and expired upon the cross, that he might teach us humility. Who shall not be humble now? Surely not the sinner who has merited so often, by his ingratitude, God's severest punishments. Humility is the source of all true greatness: pride is ever impatient, ready to be offended. He who thinks nothing is due to him, never thinks himself ill-treated; true meekness is not mere temperament, for this is only softness or weakness. To be *meek* to others, we must renounce self. The Saviour adds, *lowly of heart;* this is a humility to which the will entirely consents, because it is the will of God and for his glory.

—François Fénelon

JESUS, THY BLOOD AND RIGHTEOUSNESS

Jesus, Thy blood and righteousness
My beauty are, my glorious dress;
'Midst flaming worlds, in these arrayed,
With joy shall I lift up my head.

Bold shall I stand in that great day,
For who aught to my charge shall lay?
Fully absolved through these I am,
From sin and fear, from guilt and shame.

Lord, I believe Thy precious blood,
Which, at the mercy seat of God,
Forever doth for sinners plead,
For me, e'en for my soul was shed.

Lord, I believe were sinners more
Than sands upon the ocean shore,

Thou hast for all a ransom paid,
For all a full atonement made.
Amen.

<div align="right">
—Nicolaus L. von Zinzendorf;

Translation by John Wesley
</div>

THOU HIDDEN SOURCE OF CALM REPOSE

Thou hidden source of calm repose,
Thou all-sufficient love divine,
My help and refuge from my foes,
Secure I am if thou art mine;
And lo! from sin and grief and shame
I hide me, Jesus, in thy name.

Thy mighty name salvation is,
And keeps my happy soul above;
Comfort it brings, and power and peace,
And joy and everlasting love;
To me with thy dear name are given
Pardon and holiness and heaven.

Jesus, my all in all thou art,
My rest in toil, my ease in pain,
The healing of my broken heart,
In war my peace, in loss my gain,
My smile beneath the tyrant's frown,
In shame, my glory and my crown.

In want my plentiful supply,
In weakness my almighty power,
In bonds my perfect liberty,
My light in Satan's darkest hour,
In grief my joy unspeakable,
My life in death, my heaven in hell.

<div align="right">
—Charles Wesley
</div>

SON OF GOD

Son of God, if thy free grace
 Again hath raised me up,
Called me still to seek thy face,
 And given me back my hope;
Still thy timely help afford,
And all thy loving-kindness show;
 Keep me, keep me, gracious Lord,
 And never let me go.

By me, O my Savior, stand
 In sore temptation's hour;
Save me with thine outstretched hand,
 And show forth all thy power;
Oh, be mindful of thy word,
Thy all-sufficient grace bestow;
 Keep me, keep me, gracious Lord,
 And never let me go.

Give me, Lord, a holy fear,
 And fix it in my heart,
That I may from evil near
 With timely care depart.
Sin be more than hell abhorred
Till thou destroy the tyrant foe;
 Keep me, keep me, gracious Lord,
 And never let me go.

Never let me leave thy breast,
 From thee, my Savior, stray;
Thou art my support and rest,
 My true and living way,
My exceeding great reward,
In heaven above, and earth below;
 Keep me, keep me, gracious Lord,
 And never let me go.

—Charles Wesley

EIGHTEENTH CENTURY

ALL IN HIM

And can it be that I should gain
 An interest in the Savior's blood?
Died he for me, who caused his pain?
 For me? Who him to death pursued?
Amazing love! How can it be
That thou, my God, shouldst die for me?

'Tis myst'ry all: th'Immortal dies!
 Who can explore his strange design?
In vain the firstborn seraph tries
 To sound the depths of love divine.
'Tis mercy all! Let earth adore!
Let angel minds inquire no more.

He left his Father's throne above
 (So free, so infinite his grace!),
Emptied himself of all but love,
 And bled for Adam's helpless race.
'Tis mercy all, immense and free,
For, O my God, it found out me!

Long my imprisoned spirit lay,
 Fast bound in sin and nature's night.
Thine eye diffused a quick'ning ray;
 I woke; the dungeon flamed with light.
My chains fell off, my heart was free,
I rose, went forth, and followed thee.

No condemnation now I dread,
 Jesus, and all in him, is mine.
Alive in him, my living head,
 And clothed in righteousness divine,
Bold I approach th'eternal throne,
And claim the crown, through Christ my own.

EIGHTEENTH CENTURY

And this I shall prove, Till with joy I remove
To the heaven of heavens in Jesus' love.

<div style="text-align: right">—Charles Wesley</div>

JESUS, ALL-ATONING LAMB

Jesus, all-atoning Lamb,
Thine, and only thine I am;
Take my body, spirit, soul,
Only thou possess the whole!

Thou my one thing needful be;
Let me ever cleave to thee;
Let me choose the better part;
Let me give thee all my heart.

Fairer than the sons of men,
Do not let me turn again,
Leave the fountainhead of bliss,
Stoop to creature-happiness.

Whom have I on earth below?
Thee, and only thee, I know.
Whom have I in heaven but thee?
Thou art all in all to me.

All my treasure is above;
All my riches is thy love.
Who the worth of love can tell?
Infinite, unsearchable!

Thou, O love, my portion art.
Lord, thou knowst my simple heart;
Other comforts I despise—
Love be all my paradise.

Nothing else can I require;
Love fills up my whole desire.
All thy other gifts remove,
Still thou giv'st me all in love.
<div style="text-align: right">—Charles Wesley</div>

ONE SPIRIT WITH HIMSELF

He sleeps; and from his open'd Side
The mingled Blood and Water flow;
They both give Being to his Bride,
And wash his Church as white as snow.

And will He not his Purchase take
Who died to make us all His own,
One Spirit with Himself to make
Flesh of his Flesh, Bone of his Bone?

<div style="text-align: right">—Charles Wesley</div>

FULL RELIANCE ON CHRIST

When I met Peter Böhler again, he readily consented
to put the dispute upon the issue which I desired,
viz., Scripture and experience. I first consulted the
Scripture. But when I set aside the glosses of [human
beings], and simply considered the words of God,
comparing them together and endeavoring to illus-
trate the obscure by the plainer passages, I found they
all made against me, and was forced to retreat to my
last hold, that experience would never agree with the
literal interpretation of those Scriptures. Nor could I
therefore allow it to be true, till I found some living
witnesses of it. He replied, he could show me such at
any time; if I desired it, the next day. And accordingly
the next day he came again with three others, all of

whom testified of their own personal experience that a true, living faith in Christ is inseparable from a sense of pardon for all past, and freedom from all present sins. They added with one mouth that this faith was the gift, the free gift of God, and that he would surely bestow it upon every soul who earnestly and perseveringly sought it. I was now thoroughly convinced. And, by the grace of God, I resolved to seek it unto the end, (1) by absolutely renouncing all dependence, in whole or in part, upon *my* own works or righteousness, on which I had really grounded my hope of salvation, though I knew it not, from my youth up; (2) by adding to "the constant use of all the 'other' means of grace," continual prayer for this very thing, justifying, saving faith, a full reliance on the blood of Christ shed for *me*; a trust in him as *my* Christ, as *my* sole justification, sanctification, and redemption. . . .

In the evening I went very unwillingly to a society in Aldersgate Street, where one was reading Luther's Preface to the Epistle to the Romans. About a quarter before nine, while he was describing the change which God works in the heart through faith in Christ, I felt my heart strangely warmed. I felt I did trust in Christ, Christ alone for salvation, and an assurance was given me that he had taken away *my* sins, even *mine*, and saved *me* from the law of sin and death.

—John Wesley

JESUS, THE SERVANT

𝒯his is he, whom God the Father has appointed, and sent into the world, to bring back his exiles to himself, to save Sinners. This is he whom God the Father has sealed, has marked him out for that chosen person, in whom is salvation; has sealed him his commission, for the redeeming and reconciling the world to himself. As God said unto the three friends of Job, when he was angry with them, Job 42:8, *Go to my servant Job, and he shall offer sacrifice for you, he shall pray for you, for him will I accept*: so to Sinners, Go, says the Lord to my servant Jesus, he shall offer sacrifice for you, he shall make reconciliation for you, Isaiah 42:1, *Behold my Servant whom I uphold, my Elect in whom my soul delights: I have put my Spirit upon him, he shall bring forth judgment to the Gentiles*.

—John Wesley

WE NEED CHRIST

𝒥n every state we need Christ in the following respects:— (1) Whatever grace we receive, it is a free gift from Him. (2) We receive it as His purchase, merely in consideration of the price He paid. (3) We have this grace, not only from Christ, but in Him. For our perfection is not like that of a tree, which flourishes by the sap derived from its own root, but, as was said before, like that of a branch, which, united to the vine, bears fruit; but severed from it, is dried up and withered. (4) All our blessings, temporal, spiritual, and eternal, depend on His intercession for us, which is one branch of His priestly office, whereof therefore we have always equal need.

—John Wesley

THE LIVING CHRIST

Christ dwells in the soul through faith. But Christ is not a dead Christ, but a living Christ. Where he is, there he must live and work, there his holy life must go now, there the faith must reveal itself alive and powerful in Christ. Where Christ is present, there is his kingdom also, there he dominates, there he reigns. He is in the soul it has become his empire, and in it he exercises power, and it is then subject to him, and it submits to him in all humility and obedience—then it lives in his holy will and full approval.

—Jakob Denner

BORN OF THE SPIRIT

For the Son of God did not come from above to add an external form of worship to the several ways of life that are in the world, and so to leave people to live as they did before, in such tempers and enjoyments as the fashion and spirit of the world approves; but as He came down from Heaven altogether Divine and heavenly in His own nature, so it was to call mankind to a Divine and heavenly life; to the highest change of their own nature and temper; to be born again of the Holy Spirit; to walk in the wisdom and light and love of God, and to be like Him to the utmost of their power; to renounce all the most plausible ways of the world, whether of greatness, business, or pleasure; to a mortification of all their most agreeable passions; and to live in such wisdom, and purity, and holiness, as might fit them to be glorious in the enjoyment of God to all eternity.

—William Law

THE DIVINE FURNACE

*J*esus has shown me the only path which leads to this divine furnace of love. It is the complete abandonment of a baby sleeping without a fear in its father's arms. "Whoever is a little one, let him come unto Me," the Holy Ghost has said through Solomon's mouth. In His name the prophet Isaias reveals that on the last day the Lord "shall feed His flock like a shepherd: He shall gather together the lambs with His arm, and shall take them up in His bosom." And if this is not enough, the same prophet cries in the name of the Lord: "You shall be carried at the breasts and upon the knees they shall caress you. As one whom the mother caresseth, so will I comfort you."

Oh, dearest, dearest sister, what is there to do after such words but stay still and weep with gratitude and love? If people who are as weak and imperfect as I am only felt what I feel, not one of them would despair of scaling the summit of the mountain of love. Jesus does not demand great deeds. All He wants is self-surrender and gratitude.

—Thérèse of Lisieux

ALL DESCRIPTIONS FALL SHORT

The love of Christ in its sweetness, its fulness, its greatness, its faithfulness, passeth all human comprehension. Where shall language be found which shall describe His matchless, His unparalleled love towards the children of men? It is so vast and boundless that, as the swallow but skimmeth the water, and diveth not into its depths, so all descriptive words but touch the surface, while depths immeasurable lie beneath. Well might the poet say,

"O love, thou fathomless abyss!"

for this love of Christ is indeed measureless and fathomless; none can attain unto it. Before we can have any right idea of the love of Jesus, we must understand His previous glory in its height of majesty, and His incarnation upon the earth in all its depths of shame. But who can tell us the majesty of Christ? When He was enthroned in the highest heavens He was very God of very God; by Him were the heavens made, and all the hosts thereof. His own almighty arm upheld the spheres; the praises of cherubim and seraphim perpetually surrounded Him; the full chorus of the hallelujahs of the universe unceasingly flowed to the foot of His throne: He reigned supreme above all His creatures, God over all, blessed for ever. Who can tell His height of glory then? And who, on the other hand, can tell how low He descended? To be a man was something, to be a man of sorrows was far more; to bleed, and die, and suffer, these were much for Him who was the Son of God; but to suffer such unparalleled agony—to endure a death of shame and desertion by His Father, this is a depth of condescending love which the most inspired mind must utterly fail to fathom. Herein is love! and truly it is

love that "passeth knowledge." O let this love fill our hearts with adoring gratitude, and lead us to practical manifestations of its power.

—Charles Spurgeon

TRANSFORMATION THROUGH CHRIST

We are to be delivered from the power of sin, and are to be made perfect in every good work to do the will of God. "Beholding as in a glass the glory of the Lord," we are to be actually "changed into the same image from glory to glory, even as by the Spirit of the Lord." We are to be transformed by the renewing of our minds, that we may prove what is that good, and acceptable, and perfect will of God. A real work is to be wrought in us and upon us. Besetting sins are to be conquered; evil habits are to be overcome; wrong dispositions and feelings are to be rooted out, and holy tempers and emotions are to be begotten. A positive transformation is to take place. So at least the Bible teaches. Now, somebody must do this. Either we must do it for ourselves, or another must do it for us. We have most of us tried to do it for ourselves at first, and have grievously failed; then we discover, from the Scriptures and from our own experience, that it is something we are unable to do, but that the Lord Jesus Christ has come on purpose to do it, and that He will do it for all who put themselves wholly into His hands and trust Him without reserve. Now, under these circumstances, what is the part of the believer, and what is the part of the Lord? Plainly the believer can do nothing but trust; while the Lord, in whom he trusts, actually does the work intrusted to Him.

—Hannah Whitall Smith

THE UNKNOWN GUEST

\mathcal{I}t seems to me just in this way. As though Christ were living in a house, shut up in a far-off closet, unknown and unnoticed by the dwellers in the house, longing to make Himself known to them, and to be one with them in all their daily lives, and share in all their interests, but unwilling to force Himself upon their notice, because nothing but a voluntary companionship could meet or satisfy the needs of His love. The days pass by over that favored household, and they remain in ignorance of their marvellous privilege. They come and go about all their daily affairs, with no thought of their wonderful Guest. Their plans are laid without reference to Him. His wisdom to guide, and His strength to protect are all lost to them. Lonely days and weeks are spent in sadness, which might have been full of the sweetness of His presence.

But suddenly the announcement is made, "The Lord is in the house!" How will its owner receive the intelligence? Will he call out an eager thanksgiving, and throw wide open every door for the entrance of his glorious Guest? Or will he shrink and hesitate, afraid of His presence, and seek to reserve some private corner for a refuge from His all-seeing eye?

Dear friend, I make the glad announcement to thee that the Lord is in thy heart. Since the day of thy conversion He has been dwelling there, but thou hast lived on in ignorance of it. Every moment during all that time might have been passed in the sunshine of His sweet presence, and every step have been taken under His advice. But because thou knew it not, and did not look for Him there, thy life has been lonely and full of failure. But now that I make the announce-

ment to thee, how wilt thou receive it? Art thou glad to have Him? Wilt thou throw wide open every door to welcome Him in? Wilt thou joyfully and thankfully give up the government of thy life into His hands? Wilt thou consult Him about everything, and let Him decide each step for thee, and mark out every path? Wilt thou invite Him into thy innermost chambers, and make Him the sharer in thy most hidden life? Wilt thou say "Yes" to all His longing for union with thee, and with a glad and eager abandonment hand thyself and all that concerns thee over into His hands? If thou wilt, then shall thy soul begin to know something of the joy of union with Christ.

—Hannah Whitall Smith

THE LAMB OF GOD

*W*hy are you here today if not because you want to see the Lamb of God, who takes away the sin of the world? The burden that you carry has rested upon him and you may lay it upon him today. He is the redemption of our sins. . . . Look to the Lamb of God who takes away the sin of the world. Yes, open your eyes that you might see, open your heart and receive his grace. . . . Human words cannot give your soul life. Only one thing gives life: that you come to see the Lamb of God! I wish that the grace were given me to help someone here to look at the Lamb of God until the rays from the cross disperse the darkness in your heart.

—Fredrik Åhgren

THE TRUE LIGHT

O dear friend, think you well who is Christ; the same is the light that shines in darkness. It is not the light that comes out from the sun, moon, stars, and candles; but this the true light that shines on the benighted and wicked world, and guides us unto the way of salvation. The light of candle is blown away, but this is the true light of eternal life and we can in no wise blow it out. And we may take this light through Jesus Christ.

—Joseph Hardy Neesima

TRUE GRACIOUSNESS

[*A* human being's] greatness does not depend upon his learning, but upon his disinterestedness in self. Those with much learning are apt to be more selfish than the unlearned. Let us look at Christ on the cross. He is our example. O how noble, how grand, how gracious, He seems to us! Let us forget self, and offer ourselves freely for the cause of truth. Let us be also truly penitent and humble. I call this [the] greatness [of life].

—Joseph Hardy Neesima

O LOVE THAT WILT NOT LET ME GO

O Love that wilt not let me go,
I rest my weary soul in thee;
I give thee back the life I owe,
That in thine ocean depths its flow
May richer, fuller be.

O Light that followeth all my way,
I yield my flickering torch to thee;

My heart restores its borrowed ray,
That in thy sunshine blaze its day
May brighter, fairer be.

O Joy that seekest me through pain,
I cannot close my heart to thee;
I trace the rainbow through the rain,
And feel the promise is not vain,
That morn shall tearless be.

O Cross that liftest up my head,
I dare not ask to fly from thee;
I lay in dust life's glory dead,
And from the ground there blossoms red
Life that shall endless be.

—George Matheson

EVERY MOMENT FILLED WITH CHRIST'S ACTIONS

"Jesus Christ is the same yesterday, today and for ever," says the Apostle (Heb. 13:8). From the beginning of the world He was, as God, the source of the life of righteous souls. From the first moment of His incarnation, His humanity shared this prerogative of His divinity. He is working within us throughout our whole lives. The time that will elapse till the end of the world is but as a day, and this day abounds with His action. Jesus Christ lived and lives still. He began in Himself and He continues in His saints a life that will never end.

O life of Jesus! including and extending beyond all the ages of time! life working new wonders of grace at every moment! If no one is capable of understanding

all that could be written of the earthly life of Jesus, all that He did and said while He was on earth—if the Gospel merely outlines a few of its features—how many Gospels would have to be written to record the history of all the moments of this mystical life of Jesus Christ which multiplies miracles to infinity and eternity! If the beginning of His natural life is so hidden and yet so fruitful, what can be said of the effect of that life of which every age of the world is the history?

—Jean-Pierre de Caussade

SAVIOR, THEN COMFORTER

Christ came into this world, and died upon the cross, to expiate sin, and to save sinners; that after his ascension into heaven, he did not leave his work imperfect. He sent his Holy Spirit, who performed his first office by giving to the Apostles miraculous powers. His offices did not cease there; he has indeed withdrawn his miraculous gifts, but he still continues his silent but powerful operations, and that in their due order;— first, that of convincing of sin, and of changing the heart of the sinner, before he assumes the gracious character of the Comforter.

—Hannah More

CONTINUALLY INTERCEDING

*A*n additional reason why we should live in the perpetual use of prayer, seems to be, that our blessed Redeemer, after having given both the example and the command, while on earth, condescends still to be our unceasing intercessor in heaven. Can we ever cease petitioning for ourselves, when we believe that he never ceases interceding for us?

—Hannah More

JESUS' LIFE CALLS US

*C*ome, now, friends, I want a practical result. He suffered [the Cross] for you. He is up yonder, interceding for you. . . . What are you doing for Him? He has left you an example that you should follow in His steps. What were they? They were blood-tracked; they were humble steps. They were steps scorned by the world. . . . He was a man of sorrows—not His own. He had no reason to be sorrowful. He was the Father's own beloved, and He knew it, but He was a man of sorrows, and acquainted with grief. The griefs of this poor, lost, half-damned world He bore, and they were sometimes so intolerable that they squeezed the blood through His veins. Have you been following in His footsteps, in any measure? He lived not for Himself. He came not to be ministered unto, but to minister, and took upon Him the form of a servant. What are you doing? Oh! my friends, up, up, and be doing. Begin, if you have not begun—begin to-day. Ask Him to baptize you with His Spirit, and let you begin at once to follow Him in the regeneration of the Spirit. You are called by what He did for you!

—Catherine Booth

TWENTIETH CENTURY

JESUS OFFERS SOMETHING ELSE

*P*rogress in Christian life consists in an ever clearer vision of one's own misery and of the need for taking refuge in God's abyss of love, until we fully understand that Life means Him, and not us.

It is not a matter of being somewhat better humans: "You must be perfect, as your heavenly Father is perfect" (Mt. 6:48), says Jesus. And He wants us to realize that we have to be "something else" in order to be able to understand God's will. God is not aiming at our perfection, but at our heart.

Let us not trust in ourselves; let us not try to be on our own, and God will give us His life.

It is [God] who is making us truly living when we pray at the beginning of every day. Only God may make us perfect, when we love Him, by the humble love of His beloved children.

It is God who works the miracle, not us.

—Carlo Lupo

THE BEGINNING OF EVERYTHING

*J*esus Christ is the new beginning of everything. In him all things come into their own; they are taken up and given back to the Creator from whom they first came. *Christ is thus the fulfilment of the yearning of all the world's religions and, as such, he is their sole and definitive completion.* Just as God in Christ speaks to humanity of himself, so in Christ all humanity and the whole of creation speaks of itself to God—indeed, it gives itself

to God. Everything thus returns to its origin. *Jesus Christ is the recapitulation of everything* (cf. Eph. 1:10) and at the same time the fulfilment of all things in God: a fulfilment which is the glory of God.

—John Paul II

HE IS ABLE

Is He able? May *all* come? Can He deal with every phase of human need? There are those whose difficulties arise out of their body, the sick, the unemployed, the sex-obsessed. Can He deal with all these? In the days of His flesh, He had a special care for the bodies of [persons]. Did His concern with those things end when a cloud received Him out of their sight? Or does He still heal the sick, feed the hungry, and cast out the demon of uncontrollable passion from the heart of tempted men? There are those whose problem is largely a problem of the mind: the worried man, the futile and frustrated members of society, the people whose minds are haunted by fears, and the bereaved and broken hearted. . . .

When we add the complex spiritual ills of our poor race, the egotisms and the jealousies, the lovelessness and the loneliness, the absence of prayer, the pride, hypocrisy and vanity; when we add also the little sins, which are so large in their entail of evil, the idle gossip, the tainted hint, the self deceit and the limited consecration, we wonder if even Jesus can possibly meet them all. We look at the infinite variety of human need and ask "Is He able?" . . . From the laden souls of thousands who have turned wistful eyes and weary steps to Jesus, this urgent imperative question bursts, "Is He able?" and back from the released,

redeemed, exultant souls of as many thousand more crashes the triumphant answer,

. . . He is able,

He is willing, doubt no more.

—W. E. Sangster

WHY JESUS NEVER WROTE A BOOK

*H*e wrote no book: He formed no creed: He framed no code. This was His method; we have it in the text "And He chose twelve, that they might be with him." Ah! that is it. That they might be with Him. The religion of Jesus is as wide as life, and as long as life. You get the secret of Jesus only by personal contact with Him. You may read the book, learn the creed and keep the law, and still miss *Him*, because it is a matter of the Spirit. That is why we say the religion of Jesus is caught not taught. It is more a blessed contagion than a science. It is a divine infection that spreads from heart to heart. You can get it only by getting near to Christ Himself, and when you have it you can't keep it: somebody else will get it too. It permeates the whole life: it irradiates the entire being: it peeps out of the eyes and puts a new song upon the lips. I do not deprecate the study of the Book. I stress it. I do not minimize the importance of the creed. I emphasize it. I do not neglect the law. I keep it. But it is neither of book nor creed nor law that I would ask. This is my question—Do you live the life? Is there in you that quality of being that draws to higher things? Does contact with you stir other people to holy thoughts? Could it be said of you as it was said of the Apostles, "They took knowledge of them that they had been with Jesus"? There is a type of person known to medical science as "carriers." They are capable of

spreading an infection without being, in a sense, infected themselves. There is no counterpart to these people in the spiritual realm. People cannot catch the religion of Jesus from you unless you have it yourself.

—W. E. Sangster

CHRIST FREES US FROM THE PAST AND OPENS UP THE FUTURE

*A*s Christians, two things should be clear in our minds: first, the past was submerged on Christ's cross, and it has no more power on us, neither for us as individuals nor for the world history. The past of the world was canceled by Christ's action.

Second, by Christ's resurrection a new world has arisen, fulfilling a new reality: *agape*, God's love. This love is offered to us as a guarantee for the future. That mystery is hidden in God's hands, who will open up a new creation for us. Our hope in such a future is greater and stronger as we get to the heart of the idea of *agape*. Between a past which has no more impact on us and a still hidden future, as human beings we have to face the present which is given to us, and live it. . . .

Every day before God, every day listening to God. Living every day in the "new world," in view of the works that God has given us to accomplish. Today is the day of the Lord.

—Tullio Vinay

A LIFE OF LOVE

[*J*esus] worked as a carpenter until he was thirty years of age, and during his three-year ministry he worked hard. Even on his holidays he helped people and healed the sick. For that reason some people came

to Jesus and asked, "Don't you rest even on a rest day?" "No, God always works; if God rested, the world would fall; therefore, while God works, I work also." According to Christ, therefore, daily living was religion.

Because Jesus was merciful and sympathetic, he served beggars, healed people with leprosy, raised the dead, opened the eyes of people who were blind, healed those with epilepsy or convulsions, and relieved those possessed with evil spirits, like those people whom we call "possessed by a badger or a fox." He also listened to the complaints of cross-examiners and the appeal of adulterers. He gave to ex-convicts and poor people and worked for their salvation. He always sympathized with the oppressed classes. So in this way he revived all kinds of people physiologically, psychologically, socially, and religiously. In Christ's activity itself may be seen the image of God. Because Jesus applied religion to life, this Christian religion has lasted up to the present day. God reveals love. Here may be seen the unspeakable happiness of life.

—Toyohiko Kagawa

CHRIST IS THE BEST SIGN

\mathscr{I} feel that outside of Christ there is no complete revelation of God. The best sign that has come from God is Christ. In the same way the messages are broadcast over the radio, I have received the love of Christ as a radio-message from God. As we see Christ we can understand that God is love. Even though we should become lepers, or a consumptive, we may receive this call: "Long distance: God is broadcasting!" Yes, it is true, if we turn to God everything will be all right! Everyone understanding the spirit of Christ, comes

into contact with this love, which is thus broadcast. *There is no other way to know the love of God except through Christ.*

. . . Heavenly Father, when we do not understand Thy love, we go astray. Lead us on, beholding the Cross of Christ. May many come to know the deep love of God. The poor and the needy are all about us. Stretch out Thy unfailing hand of salvation to them, through Christ Jesus. Amen.

—Toyohiko Kagawa

HE COMES IN COMPLETENESS

*H*e comes to us as he is and penetrates us with his word. He reveals himself to our hearts in his wholeness. In his coming we feel the power of his love and the strength of his life. Everything else is deception and lying. Jesus Christ never comes close to anyone in a few hasty, fleeting impressions. Either he brings the whole of God's kingdom or he brings nothing. Only those who are willing to receive him completely and forever can experience him. To them it is given to know the secret of God's kingdom. To all others he veils himself in mysterious metaphors. Those who stop short of a full surrender hear parables without understanding what they mean. With seeing eyes, they see nothing; with hearing ears, they understand nothing. Those who do not want to have everything will lose the little they think they have.

—Eberhard Arnold

THE SEED OF CHRIST

*E*ach one of us has the Seed of Christ within him. In each of us the amazing and the dangerous Seed of Christ is present. It is only a Seed. It is very small, like the grain of mustard seed. The Christ that is formed in us is small indeed, but he is great with eternity. But if we dare to take this awakened Seed of Christ into the midst of the world's suffering, it will grow. That's why the Quaker work camps are important. Take a young man or young woman in whom Christ is only dimly formed, but one in whom the Seed of Christ is alive. Put him into a distressed area, into a refugee camp, into a poverty region. Let him go into the world's suffering, bearing this Seed with him, and in suffering it will grow, and Christ will be more and more fully formed in him. As the grain of mustard seed grew so large that the birds found shelter in it, so the man who bears an awakened Seed into the world's suffering will grow until he becomes a refuge for many.

—Thomas Kelly

THROUGH AND IN JESUS CHRIST

*C*hristianity means community through Jesus Christ and in Jesus Christ. No Christian community is more or less than this. Whether it be a brief, single encounter or the daily fellowship of years, Christian community is only this. We belong to one another only through and in Jesus Christ.

What does this mean? It means, first, that a Christian needs others because of Jesus Christ. It means, second, that a Christian comes to others only through Jesus Christ. It means, third, that in Jesus Christ we have been chosen from eternity, accepted in time, and united for eternity.

—Dietrich Bonhoeffer

JESUS TO ME

This is Jesus to me:
The Word made flesh.
The Bread of life.
The Victim offered for our sins on the cross.
The Sacrifice offered at the Holy Mass for the
 sins of the world and mine.
The Word—to be spoken.
The Truth—to be told.
The Way—to be walked.
The Light—to be lit.
The Life—to be lived.
The Love—to be loved.
The Joy—to be shared.
The Sacrifice—to be offered.
The Peace—to be given.
The Bread of life—to be eaten.
The Hungry—to be fed.
The Thirsty—to be satiated.
The Naked—to be clothed.
The Homeless—to be taken in.
The Sick—to be healed.
The Lonely—to be loved.
The Unwanted—to be wanted.
The Leper—to wash his wounds.
The Beggar—to give him a smile.
The Drunkard—to listen to him.
The Mental—to protect him.
The Little One—to embrace him.
The Blind—to lead him.
The Dumb—to speak for him.
The Crippled—to walk with him.
The Drug Addict—to befriend him.

TWENTIETH CENTURY

> The Prostitute—to remove from danger and
> befriend her.
> The Prisoner—to be visited.
> The Old—to be served.
>
> To me Jesus is my God
> Jesus is my Spouse.
> Jesus is my Life.
> Jesus is my only Love.
> Jesus is my All in all.
> Jesus is my Everything.
>
> <div align="right">—Mother Teresa of Calcutta</div>

JESUS WALKED AT THE MARGIN OF SOCIETY

Jesus Christ identifies himself with sinners, publicans, harlots, Samaritans, and pagans; and he manifested the gravity of sin, darkness, and corruption by taking all that on his own shoulders, by giving himself as the living sacrifice for every man, whether in the church or anywhere else. . . .

. . . Jesus Christ walked at the margin of human society, cured lepers and cripples, ministered to the destitute and wretched, and had compassion for those who were despised and very often cursed and driven out of human society. He did not ask about dogmatic correctness, about church membership, about social decency, about whether they were believers or unbelievers. He saw the man, his brother, the son and daughter of his Father. He did not establish any ecclesiastical, political, national, or other barriers between himself and man. He acted in perfect freedom. He broke all shackles on the hands and feet of his people. In his sovereign love and absolute obedience to his Father, he carried the burden of grief and sorrow, of

misery and poverty, of wretchedness and corruption, of helplessness and death. He was a perfectly free man while he was nailed to the cross and when he was dying in the agony of *"Eloi, Eloi, lama sabachthani."*

—Joseph L. Hromádka

ALWAYS WITH US

The God of the Gospel is no lonely God, self-sufficient and self-contained. . . . He exists neither *next to* man nor merely *above* him, but rather *with* him, *by* him and, most important of all, *for* him. He is *man's* God not only as Lord but also as father, brother, friend; . . .

. . . God who is the object of evangelical theology is just as lowly as he is exalted. He is exalted precisely in his lowliness.

—Karl Barth

IN SOLIDARITY WITH ALL

By considering the solidarity of God as the root of justification, the excluded person is aware that God is present in solidarity in Jesus Christ, the excluded person par excellence, and also in all others who are excluded. This fact allows the excluded person to be aware that he or she bears the image of God. Heard by God in the figure of the resurrected Jesus Christ, the excluded person recovers his or her dignity as a daughter or son of one who is the same Father of all. And these sisters and brothers celebrate in community together the gift of life that is granted by grace. Exclusion is condemned because all have freely received the right to a life of dignity.

—Elsa Tamez

ONE UNKNOWN, WITHOUT A NAME

He comes to us as One unknown, without a name, as of old, by the lake side, He came to those men who knew Him not. He speaks to us the same word: "Follow thou me!" and sets us to the tasks which He has to fulfill for our time. He commands. And to those who obey Him, whether they be wise or simple, He will reveal Himself in the toils, the conflicts, the sufferings which they shall pass through in His fellowship, and, as an ineffable mystery, they shall learn in their own experience Who He is.

—Albert Schweitzer

THE CHARACTERISTICS OF
CHRIST'S MINISTRY

No matter what our profession, it is neither possible nor proper to divorce our commitment to Christ from the routine duties of our working day. I have often been asked "How have you dealt with the many incompatibilities between politics and religion?" You may be surprised at my answer: I have never been faced with any serious conflicts between my duties as a Christian and my oaths to honor the constitution and laws of the state and country that I served. . . .

. . . In order to inspire new Christians, we must never forget the characteristics of Christ's ministry, and we must be certain that they also characterize our modern day churches. Peace, humility, concern for others, forgiveness, mercy, generosity, a willingness even to be persecuted in God's name. Jesus told us not to hate others, not to judge them, but to concentrate on our own relationship to God. We must face a disturbing question: Do "the least of these"—many of them our immediate neighbors—know that we in our

churches are ready to feed, house, nurture and protect them? It is not easy to bridge the gap between most of us Christians and others who are desperately in need, and each of us must find our own way to do so.

—Jimmy Carter

MY JOURNEY WITH CHRIST

During my long journey of faith—taken in obedience to the will of God—through the sixties and in the Birmingham jail with Martin Luther King Jr. and the Alabama Christian Movement, I was sustained by placing my wholehearted trust in the Lord and Savior Jesus Christ. Our focus was to abolish enforced racism, discrimination, and injustice. The grace of Jesus Christ grabbed hold of me, guided me, and added courage, energy, hope, confidence, and security to my life. By complete reliance on the word of God regarding the mission and atoning death of God's Son, the Lord Jesus Christ, and through prayer and fasting, I was undergirded and upheld by Christ's redeeming love and powers that were not my own. Without him, I could not have made it through those times of trial.

—Nathaniel Linsey

THE MESSAGE IS APPLICABLE TO ALL

In all my evangelistic ministry I have never felt a need to "adapt" Jesus to the many and varied nationalities, cultures, tribes, or ethnic groups to whom I have preached. I believe in contextualization. That is that we adapt our methods and terminology to the people to whom we are ministering. I try to adapt illustrations or emphasize certain truths that will help a particular audience understand the Gospel more clearly

in light of their cultural background. But the essential truths of the Gospel do not change. All things were created by Him and He sustains all creation, so the message of His saving grace is applicable to all. The facts concerning His virgin birth, His sinless life, His sacrificial and substitutionary death, His resurrection and ascension to the right hand of the Father, and the glorious hope of His return must not be diluted or distorted in any way.

Jesus is not only the Christ, He is also "God, our Lord and Savior." This is a staggering, almost incomprehensible truth: God Himself has come down on this planet in the person of His only Son. The incarnation and the full deity of Jesus are the cornerstones of the Christian faith. Jesus Christ was not just a great teacher or a holy religious leader. He was God Himself in human flesh—fully God and fully man.

—Billy Graham

A VISION OF CHRIST

\mathcal{I} remained till about half past four praying and waiting and expecting to see Krishna or Buddha, or some other Avatar of the Hindu religion; they appeared not, but a light was shining in the room. I opened the door to see where it came from, but all was dark outside. I returned inside, and the light increased in intensity and took the form of a globe of light above the ground, and in this light there appeared, not the form I expected, but the living Christ whom I had counted as dead. To all eternity I shall never forget His glorious and loving face, nor the few words which He spoke: "Why do you persecute me? See, I have died on the Cross for you and for the whole world." These words were burned into my heart as by lightning, and I fell

on the ground before Him. My heart was filled with inexpressible joy and peace, and my whole life was entirely changed. Then the old Sundar Singh died and a new Sundar Singh, to serve the Living Christ, was born.

—Sundar Singh

THE WATER OF LIFE

Christ is my Saviour. He is my life. He is everything to me in heaven and earth. Once while travelling in a sandy region I was tired and thirsty. Standing on the top of a mound I looked for water. The sight of a lake at a distance brought joy to me, for now I hoped to quench my thirst. I walked toward it for a long time, but I could never reach it. Afterwards I found out that it was a mirage, only a mere appearance of water caused by the refracted rays of the sun. In reality there was none. In a like manner I was moving about the world in search of the water of life. The things of this world—wealth, position, honour and luxury—looked like a lake, by drinking of whose waters I hoped to quench my spiritual thirst. But I could never find a drop of water to quench the thirst of my heart. I was dying of thirst. When my spiritual eyes were opened I saw the rivers of living water flowing from His pierced side. I drank of it and was satisfied. Thirst was no more. Ever since I have always drunk of that water of life, and have never been athirst in the sandy desert of this world. My heart is full of praise.

—Sundar Singh

A JOURNEY WITH CHRIST

\mathcal{D}iscipleship is rooted in the experience of an encounter with Jesus Christ. It is an encounter of friends ("No longer do I call you servants . . . but I have called you friends": Jn. 15:15) in which the Lord takes the initiative, and it is the point of departure for a journey. St. Paul speaks of this journey as "a walking according to the Spirit" (Rom. 8:4).

—Gustavo Gutiérrez

CHRIST IDENTIFIES WITH THOSE WHO SUFFER

\mathcal{T}he Lord is the one to whom we say, "Thou dost show me the path of life" (Ps. 16:11). Exactly so!

The new way that conversion and pardon opens up takes the form of an option in behalf of life. The option finds expression particularly in solidarity with those who are subject to "a premature and unjust death." The bishop and priests of Machala, Ecuador, have stated:

> As the followers of Christ that we are trying to be, we cannot fail to show our solidarity with the suffering—the imprisoned, the marginalized, the persecuted—for Christ identifies himself with them (Mt. 25:31-46). We once again assure the people of our support and our service in the fulfillment of our specific mission as preachers of the gospel of Jesus Christ who came to proclaim the good news to the poor and freedom to the oppressed (Lk. 4:18).

—Gustavo Gutiérrez

COMMUNION WITH CHRIST

\mathcal{H}e departed from our eyes," says St. Augustine, "that we should return to our own hearts and find Him there. For He departed, and lo! He is here. He would not tarry long with us, yet did He never leave us."

Now communion is a double relationship which gives to us and also asks something of us. Communion with Christ means, in some way, the sharing of His Spirit, realizing that His method of redemptive love, helping and suffering for others, may have to be our way too. Communion doesn't mean only spiritual consolation and support. And devotional fervor and communion are not the same thing. Communion means an entrance into the secret world at the heart of which Christ still stands.

In case we might be tempted to take refuge in the unworthy notion that because He suffered and triumphed for us we might get out of our share in suffering and only have the triumph, saint after saint comes forward to assure us it is not so. They assure us that the suffering which fellowship with Christ includes, means the Way of the Cross. The desolation of Christ is gladly endured with Him. No one can say exactly in what way, but, sooner or later, in some way, it means an inspired life of courage and generosity.

—Evelyn Underhill

THE COST

\mathcal{A}s we gaze and begin to see [the Christian] life in proportion, we begin also to get an inkling of what redemption means and the costs that a friend of Christ's, who desires to walk with Him and work for Him, must face. There is something wrong with a world which can only be put right at great cost. Like

good material that has been given a wrong twist, a twist felt more in some parts than in others, it is felt especially in human souls. The Incarnation is the immense act of divine love which tries to put the twist right and does so in every soul that fully and willingly accepts the yoke of Christ. The life of consecration means taking, sharing, and offering oneself as a channel of that redeeming love. That is the supreme happiness of the Christian soul.

—Evelyn Underhill

THE SECRET OF HIS IDENTITY

*J*esus kept the secret of who He was for a long time and He even kept it from those whom He had recruited as trusted helpers. Finally the truth became known, but it was not known until Jesus put the question of His identity directly. It was not sufficient for the disciples to repeat what others might say in explaining His identity; they were asked what their own conviction was. Suddenly, as by inspiration, there came to one of the men, the fisherman named Simon, the stupendous realization that Jesus was, in reality, the long expected Messiah. To know how bold this conclusion was we need to remember how slightly Jesus resembled the popular picture of what a Messiah would be. Simon's conclusion seemed to contradict nearly all of the available evidence.

The conviction which came to the simple fisherman at Caesarea-Philippi is that which stands at the heart of all the Christian creeds. The earliest creed is the little phrase, "Jesus is Lord." What this means is at once both very simple and very profound. Every sincere Christian is trying, however inadequately, to say that Jesus is "the Express Image" of the Father. If we

would know what God is, it is not enough to set our eyes upon the mountains or the stars or even the laws of nature, so brilliantly revealed in contemporary science; we must, instead, set our eyes upon *Jesus*.

—Elton Trueblood

REMEMBERING JESUS

O God, who has proven Thy love for mankind by sending us Jesus Christ our Lord, and hast illumined our human life by the radiance of His presence, I give Thee thanks for this Thy greatest gift.

For my Lord's days upon earth:
For the record of His deeds of love:
For the words He spoke for my guidance and help:
For His obedience unto death:
For His triumph over death:
For the presence of His Spirit with me now:

I thank thee, O God.

Grant that the remembrance of the blessed Life that Once was lived out on this common earth under these ordinary skies may remain with me in all the tasks and duties of his day. Let me remember—

His eagerness, not to be ministered unto, but to minister:
His sympathy with suffering of every kind:
His bravery in face of His own suffering:
His meekness of bearing, so that, when reviled, He reviled not again:
His steadiness of purpose in keeping to His appointed task:
His simplicity:
His self-discipline:

His serenity of spirit:
His complete reliance upon Thee, His Father in
Heaven.

And in each of these ways give me grace to follow in
His footsteps.

Almighty God, Father of our Lord Jesus Christ, I
commit all my ways unto Thee. I make over my soul
to Thy keeping. I pledge my life to Thy service. May
this day be for me a day of obedience and of charity, a
day of happiness and of peace. May all my walk and
conversation be such as becometh the gospel of
Christ. Amen.

—John Baillie

YET, NOT I, BUT GOD

In these remarkable passages [in the Gospel of John]
we find Jesus making the very highest claims; but they
are made in such a way that they sound rather like
disclaimers. The higher they become, the more do
they refer themselves to God, giving God all the
glory. Though it is a real man that is speaking, they
are not human claims at all: they do not claim any-
thing for the human achievement, but ascribe it all to
God. According to Barth, the holiness of Jesus means
that He did not treat His own goodness as an inde-
pendent thing, a heroic human attainment. His sin-
lessness consists in His renouncing all claim to ethical
heroism. He did not set up at all as a man confronting
God, but along with sinners—who do not take this
attitude—He threw Himself solely on God's grace.
The God-Man is the only man who claims nothing
for Himself, but all for God.

—D. M. Baillie

THE DIVINE YES

So Jesus is the Yes that God can and does rule in the inmost recesses of our hearts. He is in the subconscious mind which we can't control. There he can cleanse us and make us adequate. So he is the Yes to the fullness of the Holy Spirit. He is the Yes to the upper room. The door is open—through him. And if you take the Holy Spirit, it will make you a Christlike person.

At last, then, at long last the Divine Yes has sounded through him. Jesus is the Yes to all of God's promises: that there is a God, a Father lying behind this universe caring for all creation; that this Father is manifested in the face of Jesus Christ, for ours is a Christlike God; that humankind can be different, and life can be utterly changed; that our emptiness can become fullness as every recess of our inner and outer lives is invaded and empowered by the Holy Spirit. To all these promises Jesus Christ is the Divine Yes, and we belong to him.

If you belong to Jesus, you belong to the Kingdom that cannot be shaken through death or old age. Christianity means to say Yes to his Yes. Surrender to his will and you will be saying Yes to his Yes. The whole universe is behind it. You will walk the earth a conqueror, afraid of nothing.

—E. Stanley Jones

GET YOUR ATTENTION ON JESUS

There is one and only one place to fix your attention—on Jesus. You have one and only one completely trustable person—Jesus. Everything else may let you down. He never does, never has, and never will.

Note: "beholding the glory of the Lord." What Jesus are you to behold? Jesus the teacher? Yes. Jesus the doer? Yes. Jesus dying on the cross? Yes. Jesus rising from the dead? Yes. But you are to behold primarily and continuously the "glory of the Lord"—this Jesus who is at the right hand of final authority and includes all these, but is greater and more glorious than any one of these. For he is the sum total of these—plus! He holds eternity and time in his hands; he is the Omega, has the last word in human affairs; is available to anyone in need, available to you. Get your attention on that Jesus, and he will get you—your surrendered, obedient attention. Then all that is in him is transferred to you, all his forgiveness, grace, love, power, compassion, health—his everything.

—E. Stanley Jones

THE LORD IS MY STRENGTH

𝒯he Lord is!
He is more than tongue can tell,
Than mind can think, than heart can feel!
The Lord Is My Strength.
　　When day is done and in weariness I lay me down
　　　　　　to sleep,
　　When fear becomes a lump in my throat and an
　　　　　　illness in my stomach,
　　When the waters of temptation engulf me and I
　　　　　　strangle beneath the waves,
　　When I have thought myself empty and the
　　　　　　solution to my problem hides,
　　　Lurking in the shadows of my mind,
　　When the disease of my body tightens its grip and
　　　　　　my doctor picks up

the broken lances of his skill and knowledge and
 takes his leave,
When the tidings are of brooding clouds of war
 And of marching feet and humming planes
 moving in
 the awful rhythm of the dirge of death—
The Lord is the strength of my life.
Of whom
 and what
 shall I be afraid?

 —Howard Thurman

HOW JESUS UNDERSTOOD GOD

To Jesus, God breathed through all that is. The sparrow overcome by sudden death in its evening flight; the lily blossoming on the rocky hillside; the grass of the field and the garden path; the clouds light and burdenless or weighted down with unshed waters; the madman in chains or wandering among the barren rocks in the wastelands; the little baby in his mother's arms; the strutting arrogance of the Roman Legion; the brazen queries of the craven tax collector; the children at play or the old men quibbling in the market place; the august Sanhedrin fighting for its life amidst the impudences of Empire; the futile whisper of those who had forgotten Jerusalem; the fear-voiced utterance of the prophets who remembered—to Jesus God breathed through all that is. To him, God was Creator of life and the living substance; the Living Stream upon which all things moved; the Mind containing time, space, and all their multitudinous off-springs. And beyond all these God was Friend and Father.

 —Howard Thurman

JESUS OF NAZARETH

O sabbath rest by Galilee!
O calm of hills above,
Where Jesus knelt to share with Thee
The silence of eternity,
Interpreted by love!

In so many ways, ways beyond our own calculation
and reflection, our lives have been deeply touched
and influenced by the life and character, teaching and
spirit, of Jesus of Nazareth. He moves in and out on
the horizon of our days like some fleeting ghost. At
times when we are least aware and often least pre-
pared, some startling clear thrust of his mind moves in
upon us, upsetting the normal tempo of our ways,
reminding us of what we are, and what life is, giving
to us sometimes judgment, sometimes a wistful mur-
mur of the possibilities that lie before us, stirring
within us resolutions, activating ancient desires, kin-
dling anew dead hopes, giving to leaden spirits wings
that sweep. We owe so much to the spirit which he let
loose in the world. We think about it now in our med-
itation, gathering up all the fragments of our lives to
see if for us there can be some creative synthesis,
some wholeness, some great healing that will still
our tempests and give to us the quiet trust that God is
our Father, and we are His children living under the
shadow of His spirit.

Accept our lives, O God; we ourselves do not
know what to do with them. We place them
before Thee as they are, with no suggestions, no
hints, no attempts to order the working of Thy
spirit upon us. Accept our lives, our Father.

—Howard Thurman

WHAT ARE THESE WOUNDS?

\mathscr{I}t is not strange, indeed, that pagans and heathens and heretics in their ignorance should live in sins and die in them. Far more terrible is the perverse and sluggish coldness of those who have received the gift of faith and tasted the joy of being children of God, and who, nevertheless, are ready to throw away their inestimable heritage of peace in this life and beatitude in the next for a burden of intolerable cares in this life and damnation in the next. Devotion to Christ's merciful love for sinners turns first of all to the pierced heart of the Saviour and to His wounded hands and feet. It turns to the Cross and Eucharist, in a hopeless effort to comprehend such infinite depths of charity, but the effort is too great for our minds. The contrast between God's love and man's stupidity and ingratitude is so far beyond our powers of mind to fathom and of will to repair by love, that the sheer effort to do something about it baffles our whole spiritual vitality and drains us of all power to act. There is nothing for us to do but admit our helplessness, and look to Him in expectant silence, waiting in the darkness, trusting him to enlighten us and show us how we are to serve Him and make amends for sin. Indeed, reparation takes on a deeper meaning when we enter into this naked night of humiliation and powerlessness, by which our true relation to God, as creatures who have rebelled against their Creator, is brought home to us at last.

—Thomas Merton

AN ENCOUNTER WITH CHRIST

𝒯he New Testament asserts that the full manifestation of God is in fact a self-emptying (*kenosis*) in which God becomes man and even submits to death at the hands of men (see Phil. 2:5-11). The word of God is now not only event but person, and the entire meaning and content of the Bible is to be found, say the Apostles, not in the message about Christ but in an encounter with Christ, who is at once person and word of God and who lives as the Risen Lord. The fulness of the Bible is, then (for Christians), the personal encounter with Christ Jesus in which one recognizes him as "the one who is sent" (the Messiah or anointed Lord, *Kyrios Christos*). He contains in himself all the questions and all the answers, all the hope and all the meanings, all the problems and all the solutions. To become utterly committed to this person and to share in the event which is his coming, his death, and his resurrection is to find the meaning of existence, not by figuring it out but by living it as he did.

—Thomas Merton

JESUS LOVES EQUALLY

𝒯 am a fifth girl child of an Indonesian Chinese family of nine children. My mother gave birth to five girls before three sons and another sister came at last. Because of the patriarchal and patrilineal structure of the Chinese family, to produce a male heir used to be the most important responsibility of women in marriage. Therefore, my brothers are given the most of the attention. In my tradition, girls and boys are not treated equally.

When I became a Christian in my teens, I learned and came to an understanding that Jesus loved boys

and girls as well. As I was often sick at that time, it was such a comfort for me to read the story of [how] Jesus healed Jairus' little daughter (Mk. 5:21-24a, 34-35) and revived her. I believed that he loved me as he loved my brothers, and he will always take care of me.

Coming from the background of tradition that teaches hierarchical social relation, now as a Christian I have new insight of Jesus teaching equality of the sexes. I realise that Jesus advocates equality of the humankind (cf. Gal. 3:28), because God fashioned humankind, male and female, after God's own image and likeness.

—Indriani Bone

WHAT WILL WE DO WITH JESUS?

\mathcal{N}ow, the important issue is: What should we do with this unique Jesus?

Jesus said, "Come and follow me."

The following of Christ is what distinguishes Christians from other people. Christians are ultimately dependent on Jesus Christ. Not only that, but Christians are also dependent on His teaching, His life, death, and new life.

The verb used in the New Testament for "following" means "walking behind." Walking behind someone is not a requirement, but an invitation. Not a "must," but a "may." Following Jesus is a grace, a special gift, a meaningful experience, and even a joyous surprise. If we get a surprise, what would we do? We would jump with happiness and shout, "Look! What do I get here?" We would share this joy with others.

Is that what we do with Jesus? Do we share him with our friends and neighbors? Do we share him with people in other countries?

—Andar Ismail

CHRIST IS RISEN

Christ is risen, Christ is living,
Dry your tears, be unafraid!
Death and darkness could not hold him,
Nor the tomb in which he lay.
Do not look among the dead
For one who lives forever more;
Tell the world that Christ is risen,
Make it known he goes before.

If the Lord had never risen,
We'd have nothing to believe;
But his promise can be trusted:
"You will live, because I live."
As we share the death of Adam,
So in Christ we live again;
Death has lost its sting and terror,
Christ the Lord has come to reign.

Death has lost its old dominion,
Let the world rejoice and shout!
Christ, the firstborn of the living,
Gives us life and leads us out.
Let us thank our God, who causes
Hope to spring up from the ground.
Christ is risen, Christ is giving
Life eternal, life profound.

—Nicolás Martínez;
Translation by Fred Kaan

CHRIST'S RESURRECTION AS A FACT

I started to read St. Mark's Gospel. While I was reading the beginning of St. Mark's Gospel, before I reached the third chapter, I suddenly became aware that on the other side of my desk there was a presence. And the certainty was so strong that it was Christ standing there that it has never left me. This was the real turning point. Because Christ was alive and I had been in his presence I could say with certainty that what the Gospel said about the crucifixion of the prophet of Galilee was true, and the centurion was right when he said, "Truly he is the Son of God." It was in the light of the Resurrection that I could read with certainty the story of the Gospel, knowing that everything was true in it because the impossible event of the Resurrection was to me more certain than any event of history. History I had to believe, the Resurrection I knew for a fact.

—Anthony Bloom

DO YOU LOVE ME?

*L*ook at Jesus. The world did not pay any attention to him. He was crucified and put away. His message of love was rejected by a world in search of power, efficiency, and control. But there he was, appearing with wounds in his glorified body to a few friends who had eyes to see, ears to hear, and hearts to understand. This rejected, unknown, wounded Jesus simply asked, "Do you love me, do you really love me?" He whose only concern had been to announce the unconditional love of God had only one question to ask, "Do you love me?"

—Henri J. M. Nouwen

JESUS IS CRUCIFIED

*A*fter the humiliation of nakedness, Jesus is subjected to the physical agony of having great spikes hammered through his wrists to stake his arms upon the cross-beam on which he lies. The beam is then raised until it fits into its socket in the upright beam. Jesus hangs suspended from the spikes hammered through his wrists. A third great spike is driven through his ankles.

Since every crucified person is labeled with a placard, Jesus' cross bears a placard reading, "Jesus of Nazareth, King of the Jews." The Judean authorities do not like the wording but Pilate, disgusted, insists that it remain as he had dictated. Members of the crowd jeer or are silently appalled.

Jesus himself says, "Father, forgive them, for they do not know what they are doing" (Lk. 23:34). Those who hear him do not know that it is because of our sins that he is pierced and that we die with him on his cross. They do not know that nails are not what hold him to the cross but rather his life-giving love for us.

Three condemned men hang on their crosses, slowly dying. But it is the man in the middle who holds everyone's attention, even that of his companions in agony. One of these two joins the mockers in the crowd and screams insults at him. The other man protests and, perhaps even to his own astonishment, acknowledges that Jesus really is a king. Despite his own weakness and pain, Jesus turns his head toward this man, saying, "I promise you that today you will be in paradise with me."

Let us pray:
In awe and gratitude we stand before the mystery of
 the Cross;
Here we know that God loved the world so much that

God gave his Son to this kind of suffering and this
 kind of death;
That Jesus accepted this suffering and death out of
 love for us so that we may share his risen life;
We acclaim Jesus as the Christ, fountain of our
 salvation and healing;
Lord have mercy.
Christ have mercy.
Lord have mercy.

—John L. Peterson

HOPE OF THE WORLD

Hope of the world, thou Christ of great compassion,
Speak to our fearful hearts by conflict rent.
Save us, thy people, from consuming passion,
Who by our own false hopes and aims are spent.

Hope of the world, God's gift from highest heaven,
Bringing to hungry souls the bread of life,
Still let thy spirit unto us be given,
To heal earth's wounds and end all bitter strife.

Hope of the world, afoot on dusty highways,
Showing to wandering souls the path of light,
Walk thou beside us lest the tempting byways
Lure us away from thee to endless night.

Hope of the world, who by thy cross didst save us
From death and dark despair, from sin and guilt,
We render back the love thy mercy gave us;
Take thou our lives, and use them as thou wilt.

Hope of the world, O Christ o'er death victorious,
Who by this sign didst conquer grief and pain,
We would be faithful to thy gospel glorious;
Thou art our Lord! Thou dost forever reign.

—Georgia Harkness

NOTES AND PERMISSIONS

The publisher gratefully acknowledges permission to reproduce the following copyrighted material:

Aelred of Rievaulx: From *Aelred of Rievaulx: Spiritual Friendship* (Washington, DC: Cistercian Publications, 1974), 53, 112-113. Used by permission.

Agobard of Lyons: From *Early Medieval Theology*, ed. by George E. McCracken, Library of Christian Classics (Philadelphia: The Westminster Press, 1957), 334-335. Used by permission of Westminster John Knox Press.

Fredrik Åhgren: From *Vad Gud har förvarat åt Människors Barn* (Stockholm: Nya Bokförlags AB, 1925), 39. Translation by Lars Svanberg. Used by permission of the translator and the Sweden Annual Conference of the UMC.

Alexander: From *Christian Conversation* (New York: Stephen Daye Press, 1953), February 26.

Anonymous (referred to as Clement's 2nd Letter to the Corinthians): From *Early Christian Fathers*, ed. by Cyril Richardson, Library of Christian Classics (Philadelphia: The Westminster Press, 1953), 193. Used by permission of Westminster John Knox Press.

Anselm of Canterbury: From *St. Anselm of Canterbury* by J. M. Rigg (London: Methuen, 1896), 88.

Antony of Egypt: From *Early Fathers from the Philokalia* (London: Faber & Faber, 1954), 41-43. Used by permission of Faber & Faber.

John Arndt: From *True Christianity* (Philadelphia: The United Lutheran Publication House, 1868), 159-160.

Eberhard Arnold: From *Salt and Light* (Farmington, Pa: Plough Publishing, 1998), 116-117. Used by permission.

Athanasius: From *Christology of the Later Fathers*, ed. by Edward Hardy, Library of Christian Classics (Philadelphia: The Westminster Press, 1954), 63, 70. Used by permission of Westminster John Knox Press.

Augustine: From *The Confessions of St. Augustine*, trans. by Maria Boulding (Villanova, Pa: The Augustinian Heritage Institute, 1996), 209-210. Copyright 1996 Augustinian Heritage Institute. Used by permission. All rights reserved; from *The City of God*, vol. II (Edinburgh: T. & T. Clark, 1871), 441-442; from *Augustine of Hippo: Selected Writings* (New York: Paulist Press, 1984), 161-162. Copyright © 1984 by Mary T. Clark. Used by permission of Paulist Press.

D. M. Baillie: From *God Was in Christ* (New York: Charles Scribner's Sons, 1955), 127. Used by permission of Simon & Schuster.

John Baillie: From *A Diary of Private Prayer* (New York: Charles Scribner's Sons, 1952), 29. Copyright 1949 by Charles Scribner's Sons; copyright renewed © 1977 by Ian Fowler Baillie. Used by permission of Scribner's, a division of Simon & Schuster.

The Epistle of Barnabas: From *Roots of Faith* (Grand Rapids, Mich.: William B. Eerdmans Pub. Co., 1997), 45. Used by permission of Hunt & Thorpe.

Karl Barth: From *Evangelical Theology* (New York: Holt, Rinehart & Winston, 1963), 10-11. Copyright © 1963 by Karl Barth. Used by permission of Henry Holt and Company, Inc.

Bernard of Clairvaux: From *Late Medieval Mysticism*, ed. by Ray C. Petry, Library of Christian Classics (Philadelphia: The Westminster Press, 1957), 67. Used by permission of Westminster John Knox Press and SCM Press.

Birgitta: From *Hjalmar Sudén: Den Heliga Birgitta* (Stockholm: Wahlström & Widstrand, 1973), 227. Translation by Lars Svanberg. Used by permission.

Anthony Bloom: From *Beginning to Pray* (New York: Paulist Press, 1970), 10. Copyright © 1970 by Archbishop Anthony Bloom. Used by permission of Paulist Press and Darton, Longman and Todd which published the work in 1971 under the title *School for Prayer*.

Bonaventura: From *Anthology of Jesus*, ed. by James Marchant (London: Cassell & Co., 1926), 193-194.

Indriani Bone: Excerpt from her autobiography. Used by permission of Gunung Mulia.

Dietrich Bonhoeffer: From *Life Together* (New York: Harper & Brothers, 1954), 21. English translation copyright © 1954 by Harper & Brothers, copyright renewed 1982 by Helen S. Doberstein. Used by permission of HarperCollins Publishers, Inc.

Catherine Booth: From *Aggressive Christianity* (Boston: McDonald & Gill, 1883), 157-158.

John Bunyan: From *The Pilgrim's Progress* (London: Sampson Low, Marston, Searle & Rivington, 1883), 41-43.

John Calvin: From *Calvin: Institutes of the Christian Religion*, ed. by John T. McNeill, Library of Christian Classics (Philadelphia: The Westminster Press, 1960), 464, 499. Used by permission of Westminster John Knox Press.

Jimmy Carter: From Speech delivered to Baptist World Congress, July 4, 1985. Los Angeles, Calif. Used by permission.

Cassian: From *Western Asceticism*, ed. by Owen Chadwick, Library of Christian Classics (Philadelphia: The Westminster Press, 1958), 237. Used by permission of Westminster John Knox Press and SCM Press.

Catherine of Siena: From *Catherine of Siena: The Dialogue* (New York: Paulist Press, 1980), 59. Copyright © 1980 by The Missionary Society of St. Paul the Apostle in The State of New York. Used by permission of Paulist Press.

Jean-Pierre de Caussade: From *The Joy of Full Surrender*, ed. by Hal M. Helms (Orleans, Mass.: Paraclete Press, 1986), 48-49. Copyright © 1986 Paraclete Press. Used by permission.

"Christ, Mighty Savior." Trans. by Alan G. McDougall, rev. Anne LeCroy, Copyright © 1982 The United Methodist Publishing House. Administered by The Copyright Company c/o The Copyright Company, Nashville, Tenn. All Rights Reserved. International Copyright Secured. Used by permission.

Clement of Alexandria: From *Alexandrian Christianity*, ed. by Henry Chadwick and J. E. L. Oulton, Library of Christian Classics (Philadelphia: The Westminster Press, 1954), 95-96. Used by permission of Westminster John Knox Press and SCM Press.

Clement of Rome: From *Early Christian Fathers*, ed. by Cyril Richardson, Library of Christian Classics (Philadelphia: The Westminster Press, 1953), 50-51. Used by permission of Westminster John Knox Press; from *Roots of Faith* (Grand Rapids, Mich.: William B. Eerdmans Pub. Co., 1997.), 16. Used by permission of Hunt & Thorpe.

John Climacus: From *John Climacus: The Ladder of Divine Ascent* (New York: Paulist Press, 1982), 214. Copyright © 1982 by The Missionary Society of St. Paul the Apostle in The State of New York. Used by permission of Paulist Press.

The Cloud of Unknowing: From *The Cloud of Unknowing* (New York: Paulist Press 1981), 125. Copyright © 1981 by The Missionary Society of St. Paul the Apostle in The State of New York. Used by permission of Paulist Press.

Columba: "The Love Light of Christ" from *A Celtic Daily Prayer Companion* by David Adam (London: Marshall Pickering, 1997), 73.

The Council of Chalcedon: From *Documents of the Christian Church* (London: Oxford University Press, 1963), 51-52. Used by permission of Oxford University Press.

Cyril of Alexandria: From *Christian Conversation* (New York: Stephen Daye Press, 1953), February 9.

Jakob Denner: From *Readings from Mennonite Writings: New & Old*, comp. by J. Craig Haas (Intercourse, Pa.: Good Books, 1992), December 28. Used by permission of Good Books.

Dorotheus: From *Early Fathers from the Philokalia* (London: Faber & Faber, 1954), 152. Used by permission of Faber & Faber.

François Fénelon: From *Selections from the Writings of Fénelon*, by a Lady, 2nd ed., 1829 "on Meekness and Humility" as cited in *Anthology of Jesus*, ed. by James Marchant (London: Cassell & Co., 1926), 123–124.

George Fox: From *Quaker Spirituality* (New York: Paulist Press, 1984), 65-66, 134. Copyright © 1984 by Douglas V. Steere. Used by permission of Paulist Press.

Francis de Sales: From *Introduction to the Devout Life* (London: Rivingtons, 1879), 44-45, 258.

Billy Graham: From *A Biblical Standard for Evangelists* (Minneapolis, Minn.: World Wide Publications, 1984), 12–13. Used by permission.

Gregory of Nazianzus: From *Christology of the Later Fathers*, ed. by Edward Hardy, Library of Christian Classics (Philadelphia: The Westminster Press, 1954), 191-193. Used by permission of Westminster John Knox Press.

Gregory of Nyssa: From *Christian Conversation* (New York: Stephen Daye Press, 1953), March 9.

Gustavo Gutiérrez: From *We Drink From Our Own Wells* (Maryknoll, NY: Orbis Books, Melbourne: Dove Communications, 1984), 33, 100. English translation copyright © 1984 by Orbis Books. Used by permission of Orbis Books and SCM Press.

Madame Guyon: From *A Short and Easy Method of Prayer* (London: H. R. Allenson, n.d.), 54.

Georgia Harkness: From "Hope of the World" © 1954 renewed 1982 The Hymn Society of America. All rights reserved. Used by permission of Hope Publishing Co., Carol Stream, Ill. 60188.

Joseph L. Hromádka: From *Theology between Yesterday and Tomorrow* (Philadelphia: The Westminster Press, 1957), 43-44. Used by permission of the Estate of Mrs. Nadia Hromádka.

Ignatius of Antioch: From *Roots of Faith* (Grand Rapids, Mich.: William B. Eerdmans Pub. Co., 1997), 25, 27. Used by permission of Hunt & Thorpe.

Irenaeus: From *Roots of Faith* (Grand Rapids, Mich.: William B. Eerdmans Pub. Co., 1997), 111. Used by permission of Hunt & Thorpe.

Isaac of Syria: From *Early Fathers from the Philokalia* (London: Faber & Faber, 1954), 239. Used by permission of Faber & Faber.

Andar Ismail: From *Witnessing for Jesus* (Jakarta: Gunung Mulia, 1994), 10. Used by permission of Gunung Mulia.

John of Damascus: From *Saint John of Damascus: Writings*, trans. by Frederic H. Chase Jr. (New York: Fathers of the Church, vol. 37, 1958), 338-339. Used by permission of The Catholic University Press of America.

John of the Cross: From *John of the Cross: Selected Writings* (New York: Paulist Press, 1987), 128-129. Copyright © 1987 by Kieran Kavanaugh. Used by permission of Paulist Press.

John Paul II: From *On the Coming of the Third Millennium: Tertio Millennio Adveniente*, Apostolic Letter, November 19, 1994 (Washington, DC: United States Catholic Conference, 1994), 11.

E. Stanley Jones: From *The Divine Yes* (Nashville: Abingdon Press, 1975), 21. Used by permission of Abingdon Press; from *A Song of Ascents* (Nashville: Abingdon Press, 1968), 391. Used by permission of Abingdon Press.

Julian of Norwich: From *Julian of Norwich: Showings* (New York: Paulist Press, 1978), 298, 183, 315, 335. Copyright © 1978 by The Missionary Society of St. Paul the Apostle in The State of New York. Used by permission of Paulist Press.

Toyohiko Kagawa: From *New Life through God* (New York: Fleming H. Revell Company, 1931), 87-88, 164-165. Used by permission of Baker Book House.

Thomas Kelly: From *The Eternal Promise* (New York: Harper & Row, 1966), 42-43. Copyright © 1966 by Richard M. Kelly, copyright © renewed 1994 by Richard M. Kelly. Used by permission of HarperCollins Publishers, Inc.

Margery Kempe: From *Christian Conversation* (New York: Stephen Daye Press, 1953), June 10.

William Law: From *A Serious Call to a Devout & Holy Life* (London: J. M. Dent & Co., 1906), 112.

Nathaniel Linsey: Unpublished excerpt. Used by permission.

Carlo Lupo: From *Thoughts* (Torino, Italy: Claudiana, 1996), 33. Translation by Maria Sbaffi. Used by permission of the translator and libreria editrice claudiana.

Martin Luther: From *Basic Luther* (Springfield, Ill.: Templegate Publishers, 1984), 108–109, 115. Used by permission; from *Luther's Works*, vol. 26, ed. by Jaroslav Pelikan (St. Louis, Mo.: Concordia Publishing House, 1963), 30. Used by permission.

Mark the Ascetic: From *Early Fathers from the Philokalia* (London: Faber & Faber, 1954), 80, 92. Used by permission of Faber & Faber.

Nicolás Martínez: From "Christ is Risen, Christ is Living" ("¡Cristo Vive!") trans. by Fred Kaan. Copyright © 1974 by Hope Publishing Co., Carol Stream, Ill. 60188. All rights reserved. Used by permission.

Rabanus Maurus of Mainz: From *Early Medieval Theology*, ed. by George E. McCracken, Library of Christian Classics (Philadelphia: The Westminster Press, 1957), 303. Used by permission of Westminster John Knox Press.

Maximus the Confessor: From *Maximus Confessor: Selected Writings* (New York: Paulist Press, 1985), 150, 162. Copyright © 1985 by George Berthold. Used by permission of Paulist Press.

Mechthild of Magdeburg: From *Mechthild of Magdeburg: The Flowing Light of the Godhead* (New York: Paulist Press, 1998), 284-285, 294-295. Copyright © 1998 by Frank Tobin. Used by permission of Paulist Press.

Thomas Merton: From *Opening the Bible* (Collegeville, Minn., Philadelphia: The Liturgical Press, Fortress Press, 1970), 79. Used by permission of the Merton Legacy Trust; from *What Are These Wounds?* (Milwaukee: The Bruce Publishing Company, 1948), 71. Used by permission of the Merton Legacy Trust.

Hannah More: From *The Spirit of Prayer in Devotions at Home* (Boston: James Loring, 1838), 61, 176.

Thomas More: From *The Tower Works: Devotional Writings*, ed. by Garry Haupt (New Haven: Yale University Press, 1980), 88-89. Copyright © 1980 by Yale University. Used by permission of Yale University Press.

Joseph Hardy Neesima: From *Life and Letters of Joseph Hardy Neesima* (Boston: Houghton, Mifflin, 1892), 261, 54.

Niceta of Remesiana: From *St. Niceta of Remesiana* (Fathers of the Church, vol. 7). Used by permission of The Catholic University Press of America.

Nicholas of Cusa: From *Late Medieval Mysticism*, ed. by Ray C. Petry, Library of Christian Classics (Philadelphia: The Westminster Press, 1957), 371–372. Used by permission of Westminster John Knox Press and SCM Press.

Henri J. M. Nouwen: From *In the Name of Jesus* (New York: Crossroad, 1990), 23–24. Used by permission of The Crossroad Publishing Company and Darton, Longman & Todd, Ltd.

"O Come, O Come, Emmanuel" sts. 1, 3, 5ab, 6cd © 1940, 1943, renewed 1981 Church Pension Fund. Used by permission of Church Publishing Corporation.

Origen: From *Alexandrian Christianity*, ed. by Henry Chadwick and J. E. L. Oulton, Library of Christian Classics (Philadelphia: The Westminster Press, 1954), 427, 455. Used by permission of Westminster John Knox Press and SCM Press.

Patrick: From *Christian Conversation* (New York: Stephen Daye Press, 1953), March 17.

Isaac Penington: From *Quaker Spirituality* (New York: Paulist Press, 1984), 147, 143. Copyright © 1984 by Douglas V. Steere. Used by permission of Paulist Press.

John L. Peterson: From *A Walk in Jerusalem: Stations of the Cross* (Harrisburg, Pa.: Morehouse Publishing, 1998), 37, 39. Copyright © 1998 John L. Peterson. Used by permission of Morehouse Publishing.

Olaus Petri: From *Skrifter i Urval* (Stockholm: Natur och Kuhur, 1968), 210. Translation by Lars Svanberg. Used by permission.

Polycarp of Smyrna: From *Anthology of Jesus*, ed. by James Marchant (London: Cassell & Co., 1926), 288; from *Roots of Faith* (Grand Rapids, Mich.: William B. Eerdmans Pub. Co., 1997), 55. Used by permission of Hunt & Thorpe.

Pseudo-Macarius: From *Pseudo-Macarius* (New York: Paulist Press, 1992), 195, 223. Copyright © 1992 by George A. Maloney. Used by permission of Paulist Press.

Richard Rolle: From *Christian Conversation* (New York: Stephen Daye Press, 1953), December 15.

Jan van Ruysbroeck: From *Late Medieval Mysticism*, ed. by Ray C. Petry, Library of Christian Classics (Philadelphia: The Westminster Press, 1957), 296-297. Used by permission of Westminster John Knox Press and SCM Press.

W. E. Sangster: From *He Is Able* (London: Epworth Press, 1958), 10–11. Used by permission of The Methodist Publishing House; from *Why Jesus Never Wrote a Book* (London: Wyvern Books, 1956), 15–16. Used by permission of The Methodist Publishing House.

Albert Schweitzer: From *The Quest for the Historical Jesus* (New York: The Macmillan Company, 1959), 403.

Sundar Singh: From *With and Without Christ* (New York: Harper & Brothers, 1929), 117-118. Used by permission of HarperCollins Publishers, Inc.; from *Anthology of Jesus*, ed. by James Marchant (London: Cassell & Co., 1926), 244.

Hannah Whithall Smith: From *The Christian's Secret of a Happy Life* (Chicago: Fleming H. Revell, 1883), 27-28, 225-226.

Charles Spurgeon: From *Morning by Morning* (London: Passmore and Alabaster, 1865?), 88.

Symeon the New Theologian: From *Symeon the New Theologian: The Discourses* (New York: Paulist Press, 1980), 50. Copyright © 1980 by The Missionary Society of St. Paul the Apostle in The State of New York. Used by permission of Paulist Press.

Elsa Tamez: From *The Amnesty of Grace* (Nashville, Tenn.: Abingdon, 1993), 166. Used by permission of Abingdon Press.

Mother Teresa of Calcutta: From *My Life for the Poor: Mother Teresa's Life and Work in Her Own Words* (San Francisco: HarperSanFrancisco, 1985), 106-107. Copyright © by Jose Luis Gonzalez-Balado and Janet N. Playfoot. Used by permission of HarperCollins Publishers, Inc.

Teresa of Avila: From *The Life of Saint Teresa of Avila*, trans. by J. M. Cohen (London: Penguin Books, 1957), 148-149, 159. Copyright © 1957 by J. M. Cohen. Used by permission of Penguin Books, Ltd.; from "A Few Sweet Flowers," trans. from the Spanish by The Rev. Canon Dalton, 1857, p. 78, as cited in *An Anthology of Jesus*, ed. by James Marchant (London: Cassell & Co., 1926), 247.

Theologia Germanica: From *Theologia Germanica of Martin Luther* (New York: Paulist Press, 1980), 132. Copyright © 1980 by The Missionary Society of St. Paul the Apostle in the State of New York. Used by permission of Paulist Press.

Thérèse of Lisieux: From *The Autobiography of Saint Thérèse of Lisieux* (New York: Image Books, 1957), 150. Used by permission of Doubleday, a division of Bantam, Doubleday Dell Publishing Group, Inc.

Thomas à Kempis: From *The Imitation of Christ* (Grand Rapids, Mich.: Zondervan Publishing House, 1983), 71, 79. Copyright © 1983 by The Zondervan Corporation. Used by permission.

Howard Thurman: From *Deep is the Hunger* (New York: Harper & Brothers, 1951), 210–211. Used by permission of Friends United Press; from *The Centering Moment* (Richmond, Ind.: Friends United Press, 1969), 12, 30. Used by permission of Friends United Press.

Elton Trueblood: From *Confronting Christ* (Waco, Tex.: Word Books, 1960), 74. Used by permission of Word Publishing, Nashville, Tenn. All rights reserved.

Evelyn Underhill: From *The Ways of The Spirit* (New York: Crossroad, 1993), 181, 151. Used by permission of The Crossroad Publishing Company.

Tullio Vinay: From *The Utopia of the New World* (Torino, Italy: Claudiana, 1984), 121–123. Translation by Maria Sbaffi. Used by permission of the translator and libreria editrice claudiana.

Charles Wesley: "Son of God," "All in Him," "Jesus, All-Atoning Lamb" from *John and Charles Wesley: Selected Prayers, Hymns, Journal Notes, Sermons, Letters, and Treatises* (New York: Paulist Press, 1981), 194. Copyright © 1981 by The Missionary Society of St. Paul the Apostle in The State of New York. Used by permission of Paulist Press. "One Spirit with Himself" from *Hymns on The Lord's Supper*, no. 114 verses 2 and 6.

John Wesley: From *Works*, vol. 18 (Nashville, Tenn.: Abingdon Press, 1988), 248-250. Used by permission of Abingdon Press; from *John and Charles Wesley: Selected Prayers, Hymns, Journal Notes, Sermons, Letters, and Treatises* (New York: Paulist Press, 1981), 137. Copyright © 1981 by The Missionary Society of St. Paul the Apostle in The State of New York. Used by permission of Paulist Press; from *A Plain Account of Christian Perfection* (London: The Epworth Press, 1952), 44. Used by permission of The Methodist Publishing House.

William of St. Thierry: From *The Works of William of St. Thierry, Vol. I: On Contemplating God, Prayer, Meditations* (Spencer, Mass.: Cistercian Publications, 1971), 119–120, 131–132. Used by permission.

Roger Williams: From *The Bloudy Tenant of Persecution* as cited in *Soul Liberty* by E. Glenn Hinson (Nashville, Tenn.: Convention Press, 1975), 98.

While every effort has been made to secure permission, we may have failed in a few cases to trace or contact the copyright holder. We apologize for any inadvertent oversight or error.

INDEX OF READINGS
AND CONTRIBUTORS

Aelred of Rievaulx, 43

Agobard of Lyons, 35

Åhgren, Fredrik, 91

Alexander, 19

Anonymous (referred to as
 Clement's 2nd Letter to
 the Corinthians), 10

Anselm of Canterbury, 41

Antony of Egypt, 15–16

Arndt, John, 76

Arnold, Eberhard, 102

Athanasius, 17–18

Augustine, 22–24

Baillie, D. M., 115

Baillie, John, 114–115

Barnabas, The Epistle of, 8

Barth, Karl,106

Bernard of Clairvaux, 45–46

Birgitta, 51

Bloom, Anthony, 124

Bonaventura, 47

Bone, Indriani, 121–122

Bonhoeffer, Dietrich, 103

Booth, Catherine, 95

Bunyan, John, 71–72

Calvin, John, 69–70

Carter, Jimmy, 107–108

Cassian, 25

Catherine of Siena, 53–54

Caussade, Jean-Pierre de,
 93–94

"Christ, Mighty Savior," 39

Clement of Alexandria, 13

Clement of Rome, 5–6

Climacus, John, 32

Cloud of Unknowing, The, 55

Columba, 29

Council of Chalcedon, The,
 27

Cyril of Alexandria, 26

Denner, Jakob, 86

Dorotheus, 29

Fénelon, François, 77–78

Fox, George, 74–75

Francis de Sales, 72–73

Graham, Billy, 108–109

Gregory of Nazianzus, 15

Gregory of Nyssa, 16

Gutiérrez, Gustavo, 111

Guyon, Madame, 75

Harkness, Georgia, 126

Hromádka, Joseph L.,
 105–106

Ignatius of Antioch, 8–9

Irenaeus, 11

Isaac of Syria, 31

Ismail, Andar, 122

John of Damascus, 33–34

John of the Cross, 68–69

John Paul II, 97–98

Jones, E. Stanley, 116–117

Julian of Norwich, 51–52

Kagawa, Toyohiko, 100–102

Kelly, Thomas, 103

Kempe, Margery, 59

Law, William, 86

Linsey, Nathaniel, 108

Lupo, Carlo, 97

Luther, Martin, 63–65
Mark the Ascetic, 18
Martínez, Nicolás, 123
Matheson, George, 92–93
Maurus of Mainz, Rabanus, 36
Maximus the Confessor, 31–32
Mechthild of Magdeburg, 48–49
Merton, Thomas, 120–121
More, Hannah, 94–95
More, Thomas, 67–68
Neesima, Joseph Hardy, 92
Niceta of Remesiana, 20
Nicholas of Cusa, 59–60
Nouwen, Henri J. M., 124
"O Come, O Come, Emmanuel," 37
Origen, 14
Patrick, 26–27
Penington, Isaac, 74
Peterson, John L., 125–126
Petri, Olaus, 65
Polycarp of Smyrna, 7
Pseudo-Macarius, 24–25
Rolle, Richard, 56
Ruysbroeck, Jan van, 54–55

Sangster, W. E., 98–100
Schweitzer, Albert, 107
Singh, Sundar, 109–110
Smith, Hannah Whithall, 89–91
Spurgeon, Charles, 88–89
Symeon the New Theologian, 41–42
Tamez, Elsa, 106
Teresa of Calcutta, Mother, 104–105
Teresa of Avila, 65–67
Theologia Germanica, 57
Thérèse of Lisieux, 87
Thomas à Kempis, 60–61
Thurman, Howard, 117–119
Trueblood, Elton, 113–114
Underhill, Evelyn, 112–113
Vinay, Tullio, 100
Watts, Isaac, 77
Wesley, Charles, 79–83
Wesley, John, 83–85
William of St. Thierry, 44–45
Williams, Roger, 72
Zinzendorf, Nicolaus L. von, 78–79

2000
YEARS
SINCE
BETHLEHEM

Thank you,

Neil L. Irons